CALAMITY JANE
—————— AND ——————
HER SIBLINGS

CALAMITY JANE

—————— AND ——————

HER SIBLINGS

★ ★ ★

THE SAGA OF
LENA AND ELIJAH CANARY

JAN CERNEY

THE
History
PRESS

Published by The History Press
Charleston, SC
www.historypress.net

Copyright © 2016 by Jan Cerney
All rights reserved

First published 2016

Manufactured in the United States

ISBN 978.1.46711.939.9

Library of Congress Control Number: 2016930765

Notice: The information in this book is true and complete to the best of our knowledge. It is offered without guarantee on the part of the author or The History Press. The author and The History Press disclaim all liability in connection with the use of this book.

CONTENTS

ACKNOWLEDGEMENTS

I'm indebted to several historical societies and archives that have been so helpful. I especially would like to thank the Wyoming State Archives, Department of State Parks and Cultural Resources, Cheyenne, Wyoming; the Idaho State Historical Society, Public Archives and Research Library, Boise, Idaho; St. Anthony Probate Court, St. Anthony, Idaho; and the Oregon Historical Society, Portland, Oregon. Thank you to Ken Walston of the Snake River Heritage Center Museum, Weiser, Idaho, for assisting me with photographs and information on the Canary relatives who lived in Midvale and Weiser, Idaho. William Whiteside's genealogical notes have also been valuable in conducting Canary family searches.

Online resources were so helpful, especially the Wyoming newspaper project. Without this important resource, I fear my research would have been thwarted. Genealogical sites such as ancestry.com have led me to some wonderful discoveries and connections.

And lastly, I am grateful to those authors and historians who have recently searched out the truth, dispelling most of the Calamity Jane legends. I especially want to recognize James D. McLaird's *Calamity Jane: The Woman and the Legend* and Richard W. Etulain's *The Life and Legend of Calamity Jane* and *Calamity Jane: A Reader's Guide*. Even though I conducted my own research, I referred to their works. A special thanks to Richard W. Etulain for sharing information and pointing me in the right direction to bring my work to fruition.

INTRODUCTION

Calamity Jane, born Martha Canary, needs no introduction to western history enthusiasts. Her bizarre and aberrant lifestyle turned to gold in the form of her legendary status. The myth surrounding her is larger than life, and her image has permeated western folklore for nearly a century and a half.

Unlike women of her time, Calamity garnered a great deal of attention because of her tendency to depart from female expectations. On occasion, she dressed like a man, smoked cigars, gambled, drove a team of oxen, cussed and wielded a whip and a gun. Her prodigious storytelling aided her elevation to legend.

The autobiography she wrote in 1896 has misled and confounded historians for years. Her legend hinged on her claims of serving as a scout, driving a stage, fighting Indians and involvement in other escapades a woman of her time wouldn't think of participating in. The outrageous stories were never proven.

A bottle of whiskey became her companion. Imbibing its fiery contents transformed her into a wild and ornery woman. Dime novelists and newspapers capitalized on her uniqueness and wrote a great deal of flagrant fiction. When the press interviewed Calamity, she added to the confusion by changing her stories almost as frequently as her location. She was known for her boisterous ways, her embellishment of truth and her alcoholism, but according to some of her contemporaries, it was her big heart, compassion for her fellow man and kindness that has often redeemed her memory.

INTRODUCTION

Historians have had the onerous task of peeling away the layers of legend, folklore and half-truths to find the real woman; however, few have concentrated on her brothers and sisters after they were separated upon their parents' deaths. Calamity assumed the position of big sister, finding new homes for her siblings. She was known to have visited one sister and her nieces and nephews from time to time during the course of her life, even though she failed as an upstanding role model and was often an unwelcome guest.

Unfortunately, Calamity was always highly distracted and tantalized by the next new adventure, whether it was following gold rushes, military expeditions, railroads or the advancement of settlements across the United States and the vices that often accompanied them. She was not one to settle down for any length of time or nurture a family. In fact, she was often homeless, holing up in a run-down, abandoned cabin or tent.

The purpose of this work is not to be a comprehensive view of her life, her whereabouts or all her supposed adventures. The plethora of books written about her has done this already. Instead, this book highlights sections of her life and travels to reveal a glimpse of her life story, especially when she's associated with her siblings Lena and Elijah.

However, Calamity Jane's brothers and sisters have been difficult to track. Newspapers and a few documents reveal the whereabouts of Martha's sister Lena and brother Elijah. Diligent research has produced new information about Elijah, and even Calamity Jane, and is included in this work.

And then there are the other siblings Martha briefly mentioned in her autobiography. She wrote that there were five other children besides herself, two brothers and three sisters. Two of Calamity's siblings, Lena and Elijah, have been accounted for, but the other brother and two sisters are virtually lost to history. Very few clues exist to document their existence.

From the snippets of information gathered, it appears that the Canary family members met one another from time to time during the early years, although little is known of their family encounters. Today, we may describe the Canary family as fractured. Regardless of their family dynamics, they attempted to forge familial bonds the only way they knew how, in spite of their unusual circumstances.

1

THE TRIP WEST

Billowing puffs of white canvas–topped wagons rumbled across the western prairie, leaving trails of ruts and choking dust. The brooding sky and unrelenting sun glared at the intrusive travelers angling along the well-worn route as they meandered their way west. The Canary family's wagon joined the stream of pioneers rattling along in their schooners, their focus on the golden opportunities in the West. An eight-year-old tomboy riding near the Canary wagon soaked in the land's call to adventure, relishing each new challenge from the wild frontier. But underneath her tough exterior lived the dreams of a young girl.

The eight-year-old was Martha Canary, the Canarys' eldest daughter, who would eventually be crowned with the moniker "Calamity Jane." She recalled the trip west in her pamphlet autobiography, which she dictated in 1896. She had it printed during her later years and sold it, purportedly to fund her daughter Jessie's education.

"My maiden name was Marthy Cannary," she told her ghostwriter. "I was born in Princeton, Missourri [*sic*], May 1st, 1852."[1]

Before the illiterate Martha even dictated a full paragraph, the second sentence in her autobiography rings untrue. She was born in 1856, not 1852, the date that has been perpetuated throughout her history. But this isn't the only inaccuracy to throw the reader off her trail. Her so-called autobiography progressively misled her readers.

Martha continued her dubious recollections:

> *Father and mother were natives of Ohio. I had two brothers and three sisters, I being the oldest of the children. As a child I always had a fondness for adventure and out-door exercise and especial fondness for horses which I began to ride at an early age and continued to do so until I became an expert rider being able to ride the most vicious and stubborn of horses, in fact the greater portion of my life in early times was spent in this manner.*[2]

Martha omitted many details from her first paragraph, which has frustrated those searching for her family ties. Her autobiography is about her life not her siblings. Therefore, she sees no need to name or number the children who accompanied their parents on the overland journey west. But to those who are interested in her family history, such details are important in ferreting out the birthdates and whereabouts of her brothers and sisters once they reached Montana.

Martha continued:

> *In 1865 we emigrated from our home in Missourri [sic] by the overland route to Virginia City, Montana, taking five months to make the journey. While on the way the greater portion of my time was spent in hunting along with the men and hunters of the party, in fact I was at all times with the men when there was excitement and adventures to be had. By the time we reached Virginia City I was considered a remarkable good shot and a fearless rider for a girl of my age.*[3]

Martha was only eight when she accompanied the men on their adventures. It's doubtful they would have included her in hunting at such a young age, but her audience doesn't know this. She said she was born in 1852, making her two years older than she really was. However, there may be some truth in what she said. Her relatives remembered her assuming the role of a boy when she lived in Missouri, a gender role she often played for the remainder of her life.[4]

Martha also recalled viable experiences in another portion of her autobiography during the trip across the country. Certainly many of these could have happened, and she probably did correctly remember the unexpected adventures of wagon train life. She mentioned lowering the wagons over ledges with ropes when crossing the mountains, fording swollen streams and finally arriving safely in Virginia City.

Although Calamity's autobiography has been criticized as mostly fiction, the timeline of her life, although confusing and inaccurate, does reveal some clues to her whereabouts. Since newspapers were very diligent in keeping up with her appearances when she became famous, except for a few instances during her life, their reports are valuable for determining her whereabouts and her possible connections with her brothers and sisters.

Martha's younger sister Lena Borner told her version of family history to her children; however, it differs from Martha's recollections. Lena quoted the same departure date as Martha. She told her family that in 1865, Robert Wilson Canary and his wife, Charlotte, packed their wagon with necessities for the trip west and left their home in Princeton, Missouri. Lena does name the children and their ages, which are older than they would have actually been. She stated the parents and their three children—Martha, aged thirteen; Lena Pauline, aged nine; and Elijah, five—joined a wagon train and set their sights on a new home in the West. Lena's son Tobias (Tobe) Borner told this family history to a Wyoming newspaper.[5]

Furthermore, according to Lena's accounts, Robert Canary was a Methodist minister who had joined the Mormon church and was studying the religion. Dreaming of a bright future, the family loaded their covered wagon with supplies, hitched up their yoke of oxen and joined a Mormon wagon train going to Salt Lake City. Twelve wagons led the procession when it left Garden City, but as the train traveled, more people joined, increasing the total to sixty wagons.[6]

Delilah Canary, wife of James Thornton Canary, Robert Canary's brother, may have scoffed at Lena's remembrances. While living in Missouri before either family came west, Delilah gossiped about her sister-in-law Charlotte to her friends. Delilah said Robert Canary had found his future wife in an Ohio bawdy house when she was just a young teen. Charlotte was said to frequent saloons and the company of rough men while neglecting her children and lazy, dependent husband. But she was so beautiful that Robert apparently overlooked her faults.[7]

Inconsistent with the crude tales of the Canary couple, a descendant of Delilah's passed on the family story that Robert served as a chaplain at an unidentified military post before he bought a 180-acre farm from his father, James, in 1856. He had married Charlotte Burge six years before in 1850. He also served as chaplain during the Civil War, probably in St. Louis, where chaplains were in demand, according to the relative.[8]

Furthermore, Calamity was said to criticize the press for verbally abusing her, especially when they called her a minister's daughter. She unequivocally

denied that her father was a minister.[9] Since the stories are at opposite points on the spectrum, perhaps Robert fits somewhere in the middle.

Although the family story is muddled, the Canary family was lured west on a challenging journey. Like the migrants before them, their loaded wagon creaked and groaned along an overland trail worn deep and wide. Since the migration had begun in the 1840s, the sun had bleached the bones of animals that had expired from overwork, lack of good water, feed and exposure. Mounds of rocks, slabs of carved stone and crude, weathered crosses marked graves of migrants who had died during the trek.

According to Lena, during the Canarys' trip, a band of hostile Indians raided their camp during the night and killed Robert and Charlotte while they were taking their turn guarding the livestock. Martha volunteered to go for help at a fort they had passed about ten miles back. She and the soldiers returned the next morning. The soldiers followed the trail left by the raiding party, recaptured the livestock and returned to camp. After the Canarys' burial, the wagon train left for its destination.[10]

The story is plausible; however, Martha Canary's story contrasts significantly with her sister Lena's. Martha never mentioned her parents being killed or her heroic act of going to the fort for help. Surely she wouldn't have let this act of bravery slip by.

Martha stated in her autobiography that she had two brothers and three sisters, she being the eldest. She doesn't explain which children accompanied Robert and Charlotte Canary as they traveled to Virginia City, Montana—not Virginia City, Nevada, as some newspaper sources stated.

However, one clue emerged, placing the Canary family in Montana. The Virginia City newspaper, the *Montana Post*, was aghast when it heard of three Canary waifs appearing at the home of Mr. and Mrs. Fergus in Virginia City, dressed only in calico slips to protect them against the December cold. Reporters reprimanded the parenting of the family. "A most flagrant and wanton instance of unnatural conduct on the part of parent to their children, came under our notice today." The newspaper further chastised the parents, "Inhuman brutes who have deserted their poor, unfortunate children."[11]

The Montana newspaper wrote, "Three little girls, who state their names to be Canary, appeared at the door of Mr. Fergus, on Idaho Street, soliciting charity. The ages of the two eldest were about ten and twelve, respectively. The eldest girl carried in her arms her infant sister, baby of about twelve months of age. Canary, the father, it seems, is a gambler in Nevada. The mother is a woman of the lowest grade, and was last seen in town, at

Dr. Byam's office, a day or two since…We understand that the little ones returned to Nevada, where they have existed for some time."[12]

Mrs. Fergus, Mrs. Castner and Mrs. Moon took pity on the children and provided the family with food and clothing. "Blessed are the merciful," the paper placed in quotes.[13]

Based on a newspaper article dated December 31, 1864, historians suggest 1864 as the date the Canary family arrived in Virginia City, not 1865, as Martha stated in her autobiography. Furthermore, the Canary family spent an undetermined amount of time in Iowa before beginning their journey.[14]

Apparently, Charlotte wished to say goodbye to her mother, brothers and sisters before she and her family made the trek. Charlotte's parents and some of her siblings lived in Polk, Iowa. The 1850 census listed father Henry Burge as fifty-four and mother Elizabeth as fifty-three. Five siblings were listed in the census records in addition to Charlotte. The eldest was Gideon at the age of nineteen, then Benjn at seventeen, Andrew at fifteen, Harriet at thirteen, Charlotte at ten and Elizabeth J. at eight.[15]

Charlotte's father, fifty-nine-year-old Henry Burge, died in Polk, Iowa, in 1856, the same year Martha was born. Mother Elizabeth Burge may have still been alive in 1863–64 when the Canarys stopped for a visit. Certainly, sisters and brothers may still have been in the area.[16]

First Capitol Building in Montana, 1864.

The Canary family lived for a time near Virginia City, Montana, after they came west in 1864–65. *Author's collection.*

CALAMITY JANE AND HER SIBLINGS

The two eldest Canary girls, appearing at the Fergus door in 1864, may have been Martha and Lena, even though they would have been younger than described. The twelve-month-old child could have accompanied them west, but Lena does not mention her. More than likely, she was born after they arrived in Montana. Who is she? She may have been Isabelle (Belle) or Sarah, both of whom are mentioned in a few genealogies.

To further confuse the story, some genealogy records have added the two sisters Isabelle and Sarah to the Robert W. Canary family tree. Contradictions in different genealogies confuse their birth dates. For example, Isabelle is recorded as being born in 1858 in Mercer County, Missouri, in one genealogy, but no death date is given. In another genealogy, 1866 is given as the birth and death date for Isabelle. Sarah does not appear in all of the Robert Wilson family trees. When she does, the birth date is given as 1866, with her death in the same year.[17] According to some genealogy records, their birth dates are both 1866. If this date is correct, it is possible they were twins. Did one survive and the other not?

In the Missouri 1860 census records, only three children are listed. Martha was four, a brother named Cilus was three and a younger sister Lana (Lena) was listed as one. The birth date for Martha was given as 1856, which is the correct date, even though her autobiography stated that she was born in Princeton, Missouri, on May 1, 1852. Cilus's birth date is listed as 1857. Lena's birth date is recorded as 1859.[18]

There is no mention of Elijah in the 1860 census because he was apparently born after the census was taken. Elijah told a different story about his birth, adding more uncertainty to the Canary children's early years. During his lifetime, he had always recorded he was born in Helena, Montana, sometimes stating his birth date was July 1, 1862, which was also listed on his death certificate. He said his mother died when he was an infant and his father died when he was six.[19]

Elijah gave at least two more birth dates during his lifetime: 1868 and 1867. In addition, genealogy records have used 1856 as a birth date. If his mother, Charlotte, died in 1866, then 1867 and 1868 would be incorrect as birth dates.[20]

If the Canarys traveled west in 1864, Martha's mother would have been twenty-four years old and her father thirty-nine. Martha would have been eight; Cilus, seven; and Lena, five. It's possible that Elijah would have been two, if 1862 was his birth date. Surely Lena would have remembered which brother or brothers rode in the wagon with her! She did.

A family relative recalled that Martha's father, Robert Canary, sold his Missouri farm in 1862 after Cilus died at the age of five. She further stated

Elijah would have been two then. If she was correct, Elijah would have been born in 1860 after the 1860 census was taken.[21] Therefore, he could have been six years old when his father died like he claimed, but there is no explanation why he insisted his mother died when he was an infant.

The discrepancy in birth dates for the entire family muddies the pool of genealogy. It seems birth dates were either forgotten or changed on a whim to fit the situation. Who the children were and the ages of the children when they crossed the plains and arrived in Virginia City is still uncertain.

Calamity recorded in her autobiography:

> *Mother died at Black Foot, Montana, 1866, where we buried her. I left Montana in Spring of 1866, for Utah, arriving at Salt Lake city during the summer. Remained in Utah until 1867, where my father died, then went to Fort Bridger, Wyoming Territory, where we arrived May 1, 1868, then went to Piedmont, Wyoming, with U.P. Railway. Joined General Custer as a scout at Fort Russell, Wyoming, in 1870, and started for Arizona for the Indian Campaign.*[22]

Here is where Calamity inserts her fictional life as a scout, an important part of her legend. Unfortunately, this claim has been proven false.

When Martha's mother died in Blackfoot, Montana, in 1866, Robert and the family left Montana for Salt Lake City, where he died in 1867, leaving the children as orphans. Regardless of the conflicting family history, it appears that the family migrated west, and the children, of whom the names and number are uncertain, were left homeless at early ages when their mother and father died.

The fact that each sister records a different number of children in the family and tells a completely different version of what happened to their parents is puzzling. However, both girls were quite young when they made the trip across the plains, and perhaps family members distorted the story each time it was told. Lena may be correct in her recollection of the three children who made the trip. One or two siblings may have died before 1866, when Charlotte passed on.

Regardless of conflicting information, Martha Canary and her brothers and sisters were orphaned and left to the mercies of the world. According to Lena's reminiscences, told by her son to a Wyoming newspaper, Martha sold the ox team and wagon when the orphaned siblings arrived in Salt Lake in 1865 and bought clothes for her sisters and brothers and herself. She found homes for Lena and Lige (as Elijah was sometimes called) and

found employment at a boardinghouse. Again, the date they were orphaned differs when compared to Calamity's autobiography, but then again, dates are difficult to remember.

Martha slipped into a seldom-used "we" when she used the pronoun in her autobiography, saying, "Then went to Fort Bridger, Wyoming Territory, where we arrived May 1, 1868." She only mentions her siblings once in her recollections, so it's doubtful that is was one of them. However, someone was with her when she arrived at Fort Bridger. Who could that have been? It could have been an old woman who was reported to have been caring for her. Martha ran away from her and attached herself to an army post.[23]

Much later, in a Lander interview given in 1885, Calamity told a newspaper correspondent that she "came to Miners' Delight [Hamilton City] in 1868 at the age of 11 years, the inmate of the family of Maj. Patrick A. Gallagher, an officer who has done loyal service in the civil war, as a member of a California regiment. Mrs. Gallagher had picked up the girl as the family passed through Fort Bridger."

The "we" in her autobiography couldn't have been the Gallaghers, as they picked her up at Fort Bridger.

The Lander interview contended that Martha, referred to as Jennie in the report, never knew who her parents were and that she had been lost from infancy. Mrs. Gallagher thought she was pretty and spirited and was moved to give her a home. One newspaper reported:

> But the spirit of original sin itself possessed the girl, and before they had been in their new home six months, the whole camp rang with the depraved escapes of Jennie, the only name she ever known. Young as she was she took to depravity naturally. At last an outrageous offence moved the good old Mrs. Gallagher to inflict a vigorous thrashing. Jennie raised a howl of brutal treatment, and a miners' committee investigated and came to the conclusion that if the girl was thrashed every day it wouldn't improve matters. Mrs. Gallagher now refused to have anything more to do with her, and the miners raised money to send her to the railroad. This was done, and Jennie soon made a name for herself along the line of the Union Pacific.[24]

From here onward, the direction of Martha's life was patterned to become a rootless existence, roving from one frontier town to another. As she had already sampled the vices of the wild frontier and liked them, she would become a follower of the boomtowns, railroad camps and military expeditions, where she sometimes dressed in men's clothes

to conceal her identity. She embellished all her experiences to enhance her association with high adventure when actually she was just a camp follower, entertaining the men and often becoming a nuisance in the towns she visited. During the course of her life, she seemed to wring out the worst in every place she frequented.

A newspaper article indicated that Martha lived in Piedmont, a budding railroad town, for a while after she was orphaned, but the date differs from Calamity's recollections. Martha said she went to Piedmont in 1868, three years after she crossed the country with her parents. She would have been about eleven years old. Census records verify she was in Piedmont in 1869.[25]

A man by the name of Charles Andrews who lived in Piedmont claimed Martha, who had been fourteen to fifteen years old, had been his babysitter in about 1871 during the time his mother ran a boardinghouse in Piedmont. Andrews's date differs, but he did remember that Martha babysat and helped at the boardinghouse for a few years until her taste for "social life worried his mother." Charles recalled that Martha spent most evenings dancing with soldiers, and finally, a neighbor told of seeing her dressed in a soldier's uniform at some party. "Mother blew up and fired her," Charles said.[26]

In her autobiography, Martha claimed she was in Arizona in 1871 having great adventures with the Indians, where she was involved in many dangerous missions. She was a mere fifteen and was known as a daring rider and one of the best shots in the western country. No wonder she had changed her birth date to 1852.

Then in 1872 and 1873, she claimed she was ordered to assist with the Nez Perce Indian outbreak. Here she supposedly met Generals Custer, Miles, Terry and Crook. It was during this outbreak that she claimed to have garnered the title Calamity Jane when she rescued Captain Egan falling from his horse.

It isn't surprising that her autobiography is filled with miscues. After all, she was a legend cemented on the foundation of fabricated stories. Writing about her actual life wasn't even an option.

2
SOUTH PASS CITY

S outh Pass City was a booming gold rush town when Martha came to the area looking for a good time. Located a short distance from the famous South Pass on the Oregon Trail, it sprouted into a town during the gold strike of 1867.

She had been here before with the Gallaghers at the neighboring settlement of Miner's Delight, but Martha reappeared in South Pass City after she was sent away by the miners and the Gallaghers. A local history states that Mrs. Gallagher taught school in South Pass during one or two winters, but "Jane" (Martha) was not with the Gallaghers at that time.[27]

The Sweet Water Mines engulfed three towns four miles apart: South Pass City, Atlantic City and Hamilton (Miner's Delight). South Pass City was situated in a gulch that was four to five hundred feet wide and rimmed by steep, rocky hills extending three to five hundred feet high. By 1869, twelve grocery stores, many gambling joints and saloons abounded to serve the fluctuating population.[28]

South Pass Avenue, the principal street, extended half a mile amid the log-hewn homes and numerous businesses. The boom didn't last long in South Pass City, as its principal mine, the Carissa, shut down between 1869 and 1873 for lack of surface gold–bearing ore. However, other mines in the area continued mining surface gold until they, too, were depleted by 1873.[29] But Martha took advantage of the excitement while it lasted.

The year 1874 was a turning point for both Elijah and Lena, as they had been orphaned for almost ten years. According to Tobias Borner, Martha

View of South Pass City from a hill top, circa 1974. Photographer Jack E. Boucher. *Library of Congress, Prints and Photographs Division, HABS WYO,7-SOPAC, 1-5.*

met a freighter named John Borner in South Pass City while she was working at a boardinghouse.

Tobias Borner's rendition of his family history is confusing at times and contradicts itself in reference to when Martha met Borner and also to where the Kime store was located. This is not unusual, as Tobias was only eleven years old when his mother died. One newspaper relayed:

> *Borner wintered in South Pass, working in the mines and helping to build cabins in camps until early spring. Then he made a trip to Salt Lake for Jim Kimes's store. While on this trip he got tools and grubstake intending to locate somewhere in the Popo Agie valley for the coming winter and build a ranch house. While in Salt Lake he met Martha Canarie* [Tobias spells Canary as "Canarie"] *and she made the trip with him to the mines, going to work for Mr. Kime in the hotel.*[30]

And in another paragraph, Tobias Borner said, "It was about that time [early 1870s] that my father John G. Borner, met Martha Canarie while she was working in a boardinghouse in the South Pass mining camp."[31]

South Pass City, where Mrs. Kime's boardinghouse was located. Jim Kime's store and hotel where Calamity Jane worked was in Miner's Delight. *Author's collection.*

According to local Basin historian Lylas Shovgard, the Kime store and boardinghouse were located in Miner's Delight, not South Pass City, as Tobias Borner related.[32] An article in the *Rock Springs Miner* confirmed that James Kime and "lady" were living in Miner's Delight as late as 1893.

However, another historian wrote that Mrs. Kime operated a boardinghouse from the late 1860s to the early 1870s on the west corner of Main and Price Streets in South Pass City, where the restored Carr Butcher Shop is now located. The boardinghouse was mentioned in a history of South Pass City, which stated that a spring ran in front of the building, which was enclosed with a log crib about three feet high; however, it was too close to the street's intersection. A string team with two wagons could not turn without damaging the crib curbing. To alleviate this problem, a pipe was buried underground to carry the water to Willow Creek. In addition, in 1873, Circuit Judge Jesse Knight was not pleased with the "dubious sanitation" of the facilities operated by Mrs. Kime.[33]

Mrs. Kime may have operated a boardinghouse in South Pass City, but local historians insist that Calamity Jane lived in Miner's Delight and danced in Atlantic City.[34]

Tobias Borner said of his father:

> *Johnnie Borner, as he was known at that time, was running a four-horse team and wagon between Salt Lake and the mines. He would load with clothing and groceries at Salt Lake and sell, or peddle in the way to the mines, taking back to Salt Lake, a load of coal on his return trip. Coal was in good demand there. It was on one of these trips to the mines that father was badly hurt, having a broken leg. He was taken to the rooming house where Martha was working.*[35]

Martha didn't tend only to Borner's leg; she was known for her nursing skills while living at Miner's Delight. During an epidemic to which she did not succumb, she nursed the sick while the other women were incapacitated.[36]

Tobias continued his family history:

> *After making his business known and getting acquainted with Miss Canarie, she asked to take the team and make a trip for him to Salt, Lake, taking in a load of coal and bringing back a load of goods for the store at South Pass. She made the trip with little or no trouble and brought back a load of food for the camp. Johnnie Borner, not being able to use his leg, let Martha make a second trip. The two trips took about six weeks. By this*

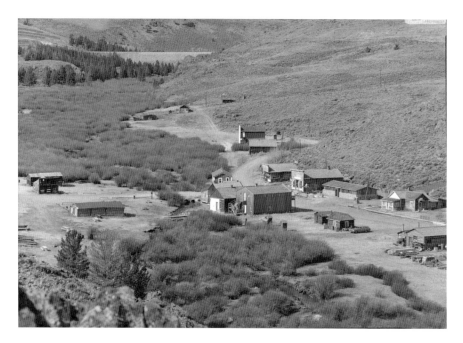

A close-up view of South Pass City, circa 1974. Photographer Jack E. Boucher. *Library of Congress Prints and Photographs Division, HABS WYO 7-SOPAC, 1-1.*

time winter was coming on and Borner was able to take the outfit back. Martha visited with her brother and sister while in Salt Lake.[37]

Regardless of when or where Martha met John Borner, she knew where Lena and Elijah were and had even visited them. If there were any more sisters, history leaves us no clues, but it was somewhere in the South Pass region that the Borners and Canarys would connect and change one another's lives.

In the meantime, John Borner continued his freighting business after he healed from his broken leg.

Borner's son Tobias continues telling his mother's story:

After delivering to Kime's store, he [Borner] made another trip to Salt Lake with freight for Fort Washakie [Camp Brown] and this time he located a ranch of 160 acres, a squatter's right in what is now the Borner's Garden district about four miles above Lander on the Sinks road. This ranch was located in 1874. At that time land was not surveyed, but a man's fence was respected as his land lines. That fall and winter Borner

John Borner married Calamity's sister Lena and brought her to a homestead near Sinks Canyon. *Wyoming State Archives, Department of State Parks and Cultural Resources, Kennedy Coll #63.*

> *built a two-room log cabin and fenced about 80 acres with a three-pole buck fence.*[38]

Ernest Hornecker, who came to the valley from Missouri with his brother John (Mart) Martin, recorded the early history of Lander and recalled that Borner had been farming on land located on the North Fork of the Popo Agie River since 1871. The region was quite uncivilized at the time; a previous farmer of that piece of land had been killed by Indians in June 1870.[39]

Sinks Canyon is located near Lander, where John Borner established his homestead. Lena came here when they married. *Author's collection.*

The remaining settlers who lived around the fort started a settlement called Pushroot, named for the rich soil that allowed the settlers to grow vegetables to sell to the mining communities. Eventually, the settlement's name was changed to Lander, and credit was given to John Borner as its founder.[40]

Borner and Hornecker farmed together in 1872, raising grain and potatoes on land near Sinks Canyon Road that later became known as Borner's Garden. Hornecker had written that there were only seven people in the valley in 1872, six men and one woman, two of whom were Hornecker and Borner.[41]

When Ernest Hornecker built his house of cottonwood logs in 1872, he cut loop holes in the walls, enabling the placement of guns. The Shoshone were friendly, but the Sioux posed a threat until after 1876. The men carried guns at all times.[42] In the spring of 1873, when John Borner built a cabin on his homestead, the Sioux killed the two female settlers, Mrs. Richards and her niece, Mrs. Hall. John was feared to have been killed, too, but he had been fishing on Squaw Creek.[43]

In the summer of 1875, before making a trip to Salt Lake for freight for the Indian agency, Borner visited with James I. Patten at Camp Brown (later called Fort Washakie). Patten said to Borner, "If you can find a woman in Salt Lake that wants to come to the fort, bring her out. I will give her work here and pay her good wages. My wife gets terribly lonesome here."[44]

Martha had wandered from place to place for nearly a decade, but apparently, she had kept tabs on her siblings and knew where they were. The next time Borner saw Martha at South Pass, he told her what Patten had said. Martha immediately seized the opportunity for Lena and Elijah. "You bring out Lena and Lige," she said. "You can take Lena down to Patten's and leave Lige with me."[45]

Raised for a time by families near Salt Lake City, Utah, Elijah and Lena were then relocated by their eldest sister, Martha, when Elijah was fifteen and Lena was eighteen.[46] Actually, Elijah may have been younger or older than fifteen, depending on when he was actually born.

When John Borner made the trip to Salt Lake, he gathered Lena (whom he later called Jennie) and her brother Elijah, who had been living with other families, and brought them back to South Pass City, where they visited for several weeks. Then Borner took Lena on to Camp Brown to work for Mrs. Patten and took Lige with him.[47]

Camp Brown was built as an outpost of Fort Bridger, 170 miles to the southwest. Since gold had been discovered near South Pass City, settlers were beginning to move into the basin. The Indians were a threat to safety in the

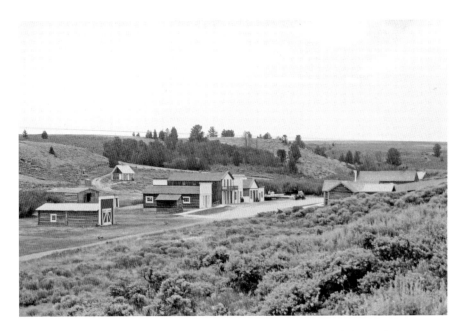

Martha lived for a time near South Pass City, the site of a gold rush. *Author's collection.*

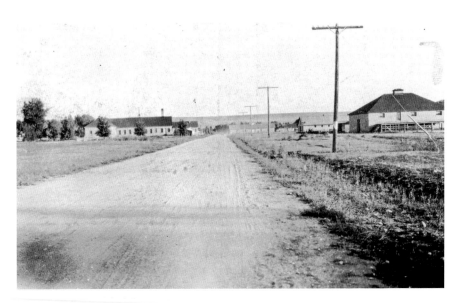

Fort Augur was renamed Camp Brown and then moved sixteen miles northwest and renamed Fort Washakie. The fort was abandoned in 1909. *Author's collection.*

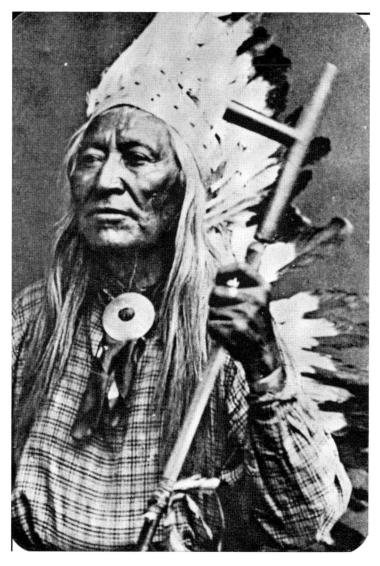

Considered a friend of the white people, Washakie, chief of the Shoshone, presented little trouble to settlers. A fort was named after him. *Author's collection.*

region, as several killings had occurred. The new fort, established as a relocated Camp Brown, was renamed in 1878 after Chief Washakie, father-in-law of Jim Bridger. The chief was the army's ally against the Sioux.[48]

The Shoshone chief Washakie insisted that his people be furnished with schools and medical facilities at the fort. His demands were written into

the 1868 treaty with the Shoshone, and an Indian boarding school was established. He lived at the fort and died in 1900 at over one hundred years of age and was buried at the fort with military honors.[49]

Undoubtedly, John Borner, Lena and Martha crossed paths with Chief Washakie at the fort. Martha would visit the fort several times during her lifetime.

According to Charles Andrews, Martha also visited Lander before her sister and brother settled there. He commented on Calamity Jane's appearances in Lander and her claim of being a teamster. Unfortunately, he does not supply a date. "We had moved to Lander—150 miles from the Union Pacific—and all that town's goods were brought in by wagons pulled by oxen, bull teams they called 'em…Calamity Jane—we called her Martha, though—used to come up with the freight trains. She had a high time in town, but she never drove a bull team." Andrews added that the last time he had seen her, she was in her early thirties. "Her married sister and brother had moved to Lander. Then she came to town."[50]

Borner, who would become an influential man in the Canarys' lives, was described as being under the average size, standing about five feet, four inches tall. He weighed only about 135 pounds. His hair was almost red and

> *his dark blue eyes were much more than ordinary; they were a wee bit sunken, yet very sharp, intelligent, and impressing one as being a bit mischievous but very shrewd. To meet him was to like him, and also to marvel that he possessed all that it takes physically to be an accomplished pioneer regardless of his size.*[51]

John Borner had emigrated from Saxony, Germany, in 1859, where he had been educated. He farmed for a short time in Wisconsin and then enlisted on September 25, 1861, in Company A, Twelfth Wisconsin Infantry, during the Civil War. After only seven months, he was admitted to the hospital with chronic hepatitis and severe diarrhea. He was discharged on December 20, 1862, because of his disability. When he healed sufficiently, he reenlisted in the Fiftieth Wisconsin and served until the conclusion of the war. He then crossed the plains to Salt Lake City and lived there for a time. In 1867, he went to South Pass City, Wyoming, where he engaged in mining for two years and then tried his hand at farming. His list of accomplishments didn't stop there. He would go on to found two towns in Wyoming.[52]

What John Borner's relationship was with Elijah is merely speculative. Elijah could ride anything that wore hair, "or wasn't afraid to try," his nephew Tobias Borner said. Described as a "rough and tumble boy," Lige was about

fifteen when he came to work for John Borner. Lige was an "excellent shot with a rifle or pistol," Tobias explained. Lige had learned to ride "the rough way" when he lived on a ranch in the Salt Lake area. Lige and the neighbor boys crowded range stock into a corral against the fence, and then the boys leaped from the fence onto the backs of the corralled animals. Lige became so good at getting stock to buck that when he worked for Borner, he taught all his best horses to buck, much to Borner's chagrin.[53]

Elijah was much like his sister, Martha Canary, possessing tendencies that could have easily annoyed John Borner. Both sister and brother were used to a rough and rugged life and possessed wandering spirits. They both were seasoned for the frontier, handy with firearms and rode horses well; however, they did not always ply their talents for the benefit of others.

THE BLACK HILLS OF DAKOTA TERRITORY

With Lena safely ensconced in Patten's care, Martha disguised herself in soldier's clothes and joined the Jenney expedition in 1875 to the Black Hills of Dakota Territory. This expedition following the 1874 Custer expedition to the Black Hills was organized to confirm that the gold discovered was of paying quantities. When her true identity was revealed, Martha was demoted to teamster only after agreeing to do the cooking. After that, she often rode in the wagon with Sam Young, a teamster. She, however, never discussed her demotion in her autobiography.[54] Her autobiography stated:

> *Was then ordered to the Black Hills to protect miners, as that country was controlled by the Sioux Indians and the government had to send the soldiers to protect the lives of the miners and settlers in that section. Remained there until fall of 1875 and wintered at Fort Laramie.*[55]

She wasn't there to protect the miners as she stated, but it was possible that Elijah accompanied Martha to the Black Hills in 1875. A Chicago correspondent wrote in June 1875, "She wanted to see the Hills; so donning a suit of blue, and taking her brother, a lad of 16, whom she supports, with her, she got into a government wagon, and, with the help of drivers and soldiers, here she is."[56]

In the subheading of the article entitled "The Gold-Hunters" is a headline that reads, "Lesser Notables…'California Joe,' 'Tige,' and

'Calamity Jane'—Their Curious Antecedents." From the headline, it may be assumed that Lige is the "Tige" mentioned.[57] By this time, Martha was going by the sobriquet Calamity Jane. A Cheyenne newspaper also verified that a woman who accompanied the soldiers to the Black Hills went by the name of Calamity Jane.[58]

A man by the name of McMillan, who had attended the World's Fair and written of the Black Hills exhibit and who had been with the Jenney expedition, recalled Calamity Jane as being the third white woman to the Black Hills. He described her as a "poor thing" and "a veritable daughter of the regiment, who dressed in men's clothes and accompanied the troops nearly six months during their wanderings."[59]

Calamity recorded in her autobiography that she left the Black Hills in the fall of 1875 and wintered at Fort Laramie. She and Elijah may have shared the trail together because, by the fall of 1875, Elijah was back at the Borners' in Sinks Canyon.

It wasn't long before John's infatuation with eighteen-year-old Lena bloomed into love. Elijah was left to care for the ranch while his sister and John Borner drove to Lander City on September 23, 1875, to be married. The thirty-four-year-old Borner escorted his new wife to a piece of land he owned at the foot of the Sinks Canyon on the Popo Agie River near Lander, Wyoming. Elijah may have lived with the newly married Borners for a time.[60]

Calamity may have been too busy when Lena's first child—May Rebecca, also known as Maybell—was born on May 4, 1876. Calamity found plenty to keep her occupied. In her autobiography, she stated:

> In spring of 1876, we were ordered north with General Crook to join Gen'ls Miles, Terry and Custer at Big Horn river. During this march I swam the Platte river at Fort Fetterman as I was the bearer of important dispatches. I had a ninety mile ride to make, being wet and cold, I contracted a severe illness and was sent back in Gen. Crook's ambulance to Fort Fetterman where I laid in the hospital for fourteen days.[61]

Calamity did sneak into Crook's command twice, once in February 1876 and another time in June 1876. General Crook did send her back to Fort Fetterman, but it wasn't because she was sick. As soon as General Crook found out she was a camp follower, he packed her off to the fort with the wounded.[62]

It's not surprising that Calamity would include an adventure associated with the campaign to bring the Sioux and Cheyenne back to their reservations that eventually resulted in the Battle of the Little Big Horn. She had been

successful in joining up with Crook's command but definitely not as a soldier. Her stories of her exploits in the army during this time period have been greatly exaggerated.

Somewhere in the mix, she was sighted at the places of prostitution, known as hog ranches, along the Cheyenne-Deadwood Trail in 1876. The Three Mile Road Ranch, three miles above Fort Laramie on the Cheyenne-Deadwood Trail, was one of the stops. Adolph Cuny and Jules Ecoffey established the road ranch in 1873 and added a store and other buildings, as well as a sod corral with hay and grain available. They advertised their ranch as offering a billiard hall, a blacksmith shop and meals at all hours. Later, as a business perk, they built eight two-room cottages for prostitutes. Calamity was said to have been one of the shady ladies who worked here. She was said to have frequented other hog ranches as well.[63]

Calamity was seen in the Black Hills as early as April 1876. Gold seekers were infiltrating the Black Hills at that time, and she accompanied them to Custer City in the southern Black Hills, where gold was originally discovered. Jack Crawford arrested her in Custer City for intoxication and disorderly conduct.[64]

On May 4, Calamity was seen on the trail from Cheyenne with a party of gold seekers. Then at the end of the month, she was in the Cheyenne jail after being arrested for grand larceny. She had allegedly stolen some women's clothing. The jury found her not guilty.[65] Afterward, she spent some time in Cheyenne and then ventured eastward once again, possibly visiting hog ranches and Fort Laramie.

Calamity continued her recollections:

> *When able to ride I started for Fort Laramie where I met Wm. Hickock,* [Hickok] *better known as Wild Bill, and we started for Deadwood, where we arrived about June.*[66]

Calamity excluded some interesting details. Wild Bill Hickok and his party of gold seekers stopped in Fort Laramie to accumulate enough members to finish the trek to Deadwood over the dangerous Cheyenne-Deadwood Trail. It was during this week that the Custer battle at the Little Bighorn in Montana was fought. An officer asked the party if they would take a young woman along with them. She had been drinking with the soldiers and causing trouble and had been locked in the guard house. Steve Utter, a member of the party, stepped forward, saying he knew this woman, Calamity Jane, and that he would take her along and take care of her. She didn't have any decent clothes and, in fact, was half naked, so

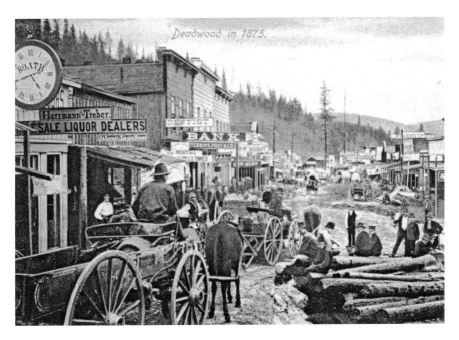

Calamity Jane was in Deadwood, Dakota Territory, several times. She came during the Black Hills gold rush. *Author's collection.*

the party gathered together some buckskin clothing that she could wear on the trail.[67]

When Hickok and his party accumulated enough members—mostly prostitutes, prospectors, gamblers, wholesale liquor men, one "respectable" family and Calamity—the group trekked to Deadwood. Hickok and his party left Fort Laramie in June 1876. Calamity was with them and so was a five-gallon keg of whiskey that Hickok had brought along for medicinal purposes and to share with his friends. By now, Calamity was a slave to whiskey and often partook of Hickok's keg.[68]

White Eye Anderson, who was along with the Hickok party, remembered Calamity as a "big-hearted woman" in spite of the tough stories she told around the campfire at night. She helped White Eye to prepare the meals and pack the grub box when they left in the morning.

After two weeks on the trail, the party arrived in Deadwood around July 12. Once they settled in, Calamity hung out about the Hickok and Utter camp, especially when she was hungry, but she did not have any romantic involvement with the married Hickok, according to White Eye Anderson.[69]

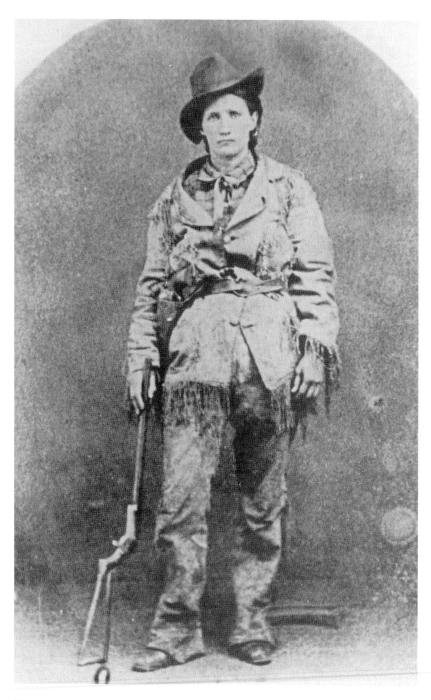

Young Calamity Jane's photograph, portraying her as a scout, was taken in Deadwood in 1876–77 by an unidentified photographer. *Author's collection.*

Calamity's sojourn in the Black Hills of Dakota Territory added to her repertoire of flagrant stories, fueling her climb to legendary status. She alleged she was a Pony Express rider in the Black Hills and had rescued a stage and its six passengers when the driver was killed by Indians. More than likely, she frequented the saloons, dance halls and, perhaps, brothels. She worked for E.A. Swearingen's at his Gem dance hall, which quickly acquired a bad reputation. Swearingen was not a nice man. He recruited young girls to Deadwood under false promises of respectable jobs. If they wouldn't work for him, they were stranded with no means to support themselves.[70]

During the years Calamity spent in Deadwood, in spite of the ruckus she caused by howling up and down the streets of Deadwood when she became inebriated, she endeared herself to some of the Black Hills residents. Deadwood remembered her nursing skills during the smallpox epidemic and her deeds of kindness to those in need. These memories would come in handy when she returned to Deadwood years later.

By 1877, Calamity Jane had made quite an impression on the region. The newspapers were beginning to report on this new western figure in their midst. Newspaperman Horatio Nelson Maguire wrote a larger-than-life sketch of Calamity, introducing her to the world. Other newspapers picked up on the story and included her in their publications, often describing her with Maguire's words, which greatly impacted her legendary status.

There was nothing in her attire to distinguish her sex, as she sat astride her fiery horse…save her small, neat-fitting gaiters and sweeping raven locks. She wore…buckskin, gaily beaded and fringed…and a broad-brimmed Spanish hat.…She comes from Virginia City, Nev. a family of respectability and intelligence.…Donning male attire in the mining regions, where no restraints were imposed for such freaks…she "took to the road," and has ever since been nomadic in her habits—now one of a hunting party, then participating in a mining stampede, again attached to and moving with a freight train; and, it is said, she has rendered service as a scout.…She has had experience as a stage-driver, and can draw the reins over six horses… and handles the revolver with dexterity, and fires it as accurately as a Texas ranger. She is still in early womanhood, and her rough and dissipated career has not altogether "swept away the lines where beauty lingers."[71]

Calamity hasn't always been remembered as beautiful. In fact, descriptions of her personal appearance vary throughout her life. In her younger years, Calamity was described by some journalists, such as Maguire, as beautiful,

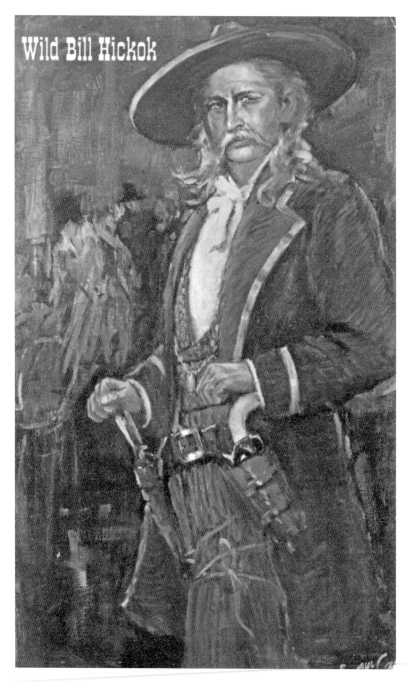

Wild Bill Hickok

Lea McCarty's oil painting is of Wild Bill Hickok, who rode into Deadwood in July 1876. Jack McCall shot him in a saloon a few weeks later. *Author's collection.*

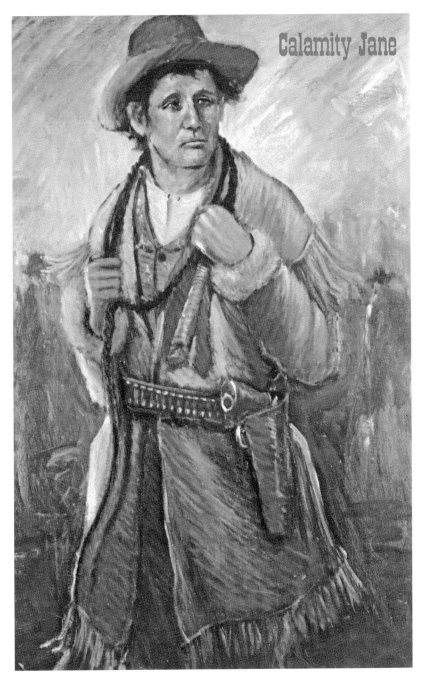

Lea McCarty also painted an oil portrait of Calamity Jane, who was known to have occasionally dressed in buckskins. *Author's collection.*

but other newspapers weren't so charitable. Clark Tingley, who had seen her in 1875, told a newspaper reporter, "She chews tobacco like an old timer and spits like a ward politician on election day." He also said she was the "hardest case he had ever met in the form of a woman."[72]

Young Mont Hawthorne saw Calamity along the trail in 1877 and described her looking like a "busted bale of hay." According to Mont, she had been drinking and talked too much and let the chewing tobacco "get away from her."[73]

Maguire may have exaggerated her attributes, but he assessed her character perfectly. He wrote she was a "mistress of her own destiny." And he added, seemingly in approval, that she chose "to stand alone in brave defiance to a frowning world."[74]

Calamity spent several years in Deadwood but not without traveling to other parts of the county. The Borner family has established that Calamity did visit her sister Lena from time to time. Lena's second child, Tobias, who was born on May 20, 1877, recalled that his mother told him Calamity was there to help his mother after the delivery, although Calamity doesn't mention any trips to Lander in her autobiography.[75]

If she was in Lander attending her nephew's birth, she didn't stay long. She made a visit to the Cheyenne newspaper office in July, where she put a scare into the editor. She introduced herself as Calamity Jane, stating she was just in from the Black Hills. The editor, hesitant to identify himself, bolted when she used her whip to strike a fly on the ceiling of his office. But that might not have been the only reason he wanted out of that room. It seemed like editors had their share of trouble when they insulted one another or the public in the press. Editors weren't too concerned with libel suits, as the courts couldn't be depended on to rectify the situation, so they solved their slanderous attacks on one another with guns and fists. It wasn't unusual for editors to be assaulted with weapons, canes or cuspidors.[76]

When Calamity came calling, the editor mumbled, "He's out. I'll go find him," and hurriedly escaped through a sky light to "find the editor" and hid in a friend's office while Calamity coerced someone to write a note that read, "Print in the *Leader* that Calamity Jane, the child of the regiment and pioneer white woman of the Black Hills is in Cheyenne, or I'll scalp you, skin you alive, and hang you to a telegraph pole. Do you hear me and don't you forget it. Calamity Jane." When the editor returned, he found his office in shambles and the note tacked to his door.[77]

Occasionally, journalists overlooked her peculiar behavior and searched for explanations. On a visit to Deadwood, an editor for a North Dakota

newspaper reported that Calamity Jane returned to the Hills in August, adding, "She waltzes on one leg and polkas on the other in the hurdy-gurdy houses to make her living." The writer included an account of Calamity's early life, defending her aberrant behavior. "At first a waif in a Mormon camp, then she passed through the mining excitements in the West, now a prostitute, now striving to mend her ways, then a scout wearing men's clothes for General Crook, then the lioness of the Hills...she deserves kind words rather than reproach."[78]

Calamity's antics supplied fodder for the newspapers during her entire life. Newspapers sometimes defended her good qualities, but most often, she was the butt of jokes and innuendos. The *Black Hills Daily Times* paid tribute to Calamity Jane by reminding Deadwood's citizens that she had many solid friends among its citizens. The paper added that she "possesses so many good and tender qualities of heart that whenever sickness or trouble overtakes her the derogatory elements of her life are not remembered by the thinking portion of our people."[79]

Calamity nursed the miners during the smallpox epidemic in Deadwood, and when she helped a man by the name of Warren who had been stabbed, the incident made the newspaper. "There's lots of humanity in Calamity, and she is deserving of much praise for the part she has taken in this particular case."[80]

On the other hand, there were other newspapers that had no use for Calamity. The respectable Alice Gossage claimed she would not print Calamity's name in the *Rapid City Journal.*[81]

Calamity recorded her early years in Deadwood, recalling her fanciful experiences:

> *I remained around Deadwood locating claims, going from camp to camp until the spring of 1877, where one morning, I saddled my horse and rode towards Crook city. I had gone about twelve miles from Deadwood, at the mouth of Whitewood creek, when I met the overland mail running from Cheyenne to Deadwood. The horses on a run, about two hundred yards from the station; upon looking closely I saw they were pursued by Indians. The horses ran to the barn as was their custom. As the horses stopped I rode along side of the coach and found the driver John Slaughter, lying face downwards in the boot of the stage, he having been shot by the Indians. When the stage got to the station the Indians hid in the bushes. I immediately removed all baggage from the coach except the mail. I then took the driver's seat and with all haste drove to Deadwood, carrying the six*

passengers and the dead driver. I left Deadwood in the fall of 1877, and went to Bear Butte Creek with the 7ᵗʰ Cavalry. During the fall and winter we built Fort Meade and the town of Sturgis. In 1878 I left the command and went to Rapid city and put in the year prospecting.[82]

No record has been found that she ever prospected, but the newspapers thought so. Calamity's nephew Frank Borner was born on November 16, 1878, but no clue exists to place her in Lander during that time. She didn't help build Fort Meade as she said, but she could have been dancing in the nearby Sturgis dance halls. She was complimented in the newspaper as the "Queen of the Demi Monde" at the Scooptown (Sturgis) dance hall.[83]

The year 1879 found Calamity relaxing on a steamboat navigating up the Missouri River. A Yankton, Dakota Territory paper, the *Yankton Press*, noted that Calamity Jane, a Black Hills character, was a passenger on the steamer *Dacotah* en route to the Black Hills via Fort Pierre. The paper wrote that she had sold her Black Hills claim for $16,000 and had enough money to buy a ranch. From Fort Pierre, Calamity would have ridden a stage or hooked a ride with a freighter on the Fort Pierre to Deadwood trail to the Black Hills. There were no railroads across the western half of Dakota Territory at that time. Calamity didn't have a claim, and there's no record of a ranch in the Black Hills.[84]

In July 1879, Rolf Johnston saw Calamity in Deadwood while touring the town. He said:

Jane is a hard customer and travels on her muscle. She is very handy with either fists or pistols and it takes a good man to get away with her. In the course of the evening I saw her "stand off" with a beerglass a big burley bullwhacker called Taylor, who was drunk and tried to impose on her.[85]

Rolf Johnson saw Calamity again in August 1879. He recalled that she was having a fit when one of the Bismarck freighters tipped over two wagons loaded with flour and grain into Whitewood Creek. According to Johnson, she cursed the bullwhacker for the accident, calling him "a tender foot and saying if she couldn't do better she would go back to the states and husk pumpkins for a living."[86]

Her autobiography recalled:

In 1879 I went to Fort Pierre and drove trains from Rapid City to Fort Pierre for Frank Wite then drove teams from Fort Pierre to Sturgis for Fred

Evans. This teaming was done with oxen for they were better fitted for the work than horses, owing to the rough nature of the country.[87]

Calamity was seen on the Deadwood trail, and she did spend time in Fort Pierre, as her autobiography stated. Whether she drove teams for freighters is speculative; however, she could handle a whip and probably could drive a team if given the chance. White Eye Anderson, her Deadwood acquaintance, recalled that she could drive a mule team as well as any man, and by using a whip and a lot of cussing, she could get them over the rough spots. Anderson also acknowledged she could use a rifle and six shooters effectively.[88]

Anyone who ever saw her didn't forget the first impression of her. Several recorded seeing her on the Fort Pierre trail. A Black Hills pioneer recalled Calamity:

I met her in '79...I was coming in and Calamity was going out and our wagons camped together about the first night out of Pierre. I said who is that loud-mouthed man and the boss said, "That ain't no man that's Calamity Jane." She stood in the middle of a great circle and cracked the bullwhip. Nobody could crack a whip like Calamity Jane. I never heard anything like it. When she made a right good crack they whooped and hollered and stopped for a drink. They just plain raised the devil around that camp.[89]

Another recollection came from Jack Sutley, who operated a road ranch on the Fort Pierre to Deadwood trail. One night he heard a knock on the door, which he opened to none other than Calamity Jane. She asked for asylum from the United States marshal who was pursuing her for selling whiskey without a government license. Not wishing to get involved, he advised her to cross the river and join the freighters, who would give her protection because she had friends among them. Sutley lent her a horse, which was a good swimmer but had the nasty habit of shaking the water off when he crossed a river. Sutley knew she reached the other side when he heard her swearing after the horse reached the shore, dousing her with sprays of water.[90]

While in Fort Pierre, Calamity often visited an old friend from Deadwood, Mary Hemphill, at her husband's road ranch near Fort Pierre. On one of her visits, she happened to arrive during a ladies' aid meeting. She entered with her usual boisterous manner, a cigar in her mouth and a black hat perched on her head. Her appearance wouldn't have bothered her, but it may have caused a fuss with the ladies.[91]

Calamity Jane has been rumored to have been associated with the Fort Pierre scourge Arkansas Putello, known as Arkansaw. He was a freighter who terrorized the Pierre citizens in the 1880s and was especially violent when he was drinking. Recognized as wild with a gun, he shot at the town citizens and those traveling the roads into the town. He didn't kill any of the citizens, but he had killed an outlaw, as well as his brother-in-law. The town citizens organized a vigilante committee to deal with his escapades, but he didn't often heed their warnings.[92]

After he killed the outlaw Texas George, who had harassed the area, the citizens felt grateful for his help and gave him a horse and saddle to clear out of town. Arkansaw sold the horse and saddle and was said to have blown the money with Calamity Jane and others of his caliber.[93]

In another incident, Calamity Jane, George Baker and others planned to start a bagnio at the end of the Northwestern track, sixty miles east of Fort Pierre, but the citizens raised a fuss, a row ensued and Baker was shot, though not fatally.[94] Whether Calamity was going to assume the job as a cook, laundress or active participant in the bagnio was not stated.

Despite her rugged ways and shady reputation, Calamity was given credit for nursing a Fort Pierre family with black diphtheria back to health, using her own money to buy groceries and medicine. The newspaper also recognized her as being an "elegant waltzer" in the Fort Pierre dance house."[95]

4

LANDER AND THE
UNION PACIFIC RAILROAD TOWNS

Calamity Jane was constantly on the move from one frontier town to another, but she returned to Lander several times over her lifetime to visit her sister Lena and her nieces and nephews, and perhaps even Elijah. The newspapers often mentioned her presence when she was there.

Frank Edward, who was born to Lena and John Borner on November 16, 1878, remembered as a small boy hiding behind his mother's skirts from a woman who had ridden up to the porch of their cabin near Lander. The woman, he later learned, was his aunt Calamity Jane. He recalled that his mother Lena asked her what she was doing there and what she wanted. Lena told Calamity to leave and never come back. Apparently, at that time, Lena had had it with her sister Martha.[96]

John Borner had taken a dislike to Calamity, mostly because of her drinking and swearing. She wasn't afraid of Borner and visited her sister when John Borner wasn't around. The Hornecker neighbors saw Calamity pass by in a buggy on her way to the Borner place when John Borner was not home. Tom Bell, a local historian, also said that Calamity often stayed at the Borner School when she came to visit her sister since she was not welcome in the Borner home.[97]

In spite of her reputation, Calamity was fond of children. Estelline Bennett, who grew up in Deadwood, remembered Calamity offering to buy her and her friend Maude candy. Estelline admitted "shaking in her shoes" but went with her to the grocery store, where Calamity threw a silver dollar on the counter and instructed the owner to give them some candy. He did, the young girls thanked Calamity politely and she left.[98]

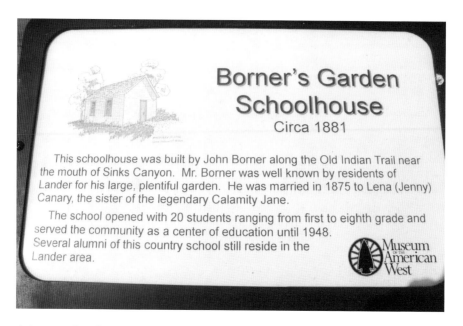

A sign near the relocated Borner Garden schoolhouse in Lander, Wyoming, explains its history. *Author's collection.*

Opposite, top: Since Calamity Jane was not welcome in the Borner home, she stayed at the Borner schoolhouse when she visited Lena and her children. *Author's collection.*

Opposite, bottom: Lander, Wyoming, is nestled at the foot of the Wind River Mountain Range. Lena Borner and her family lived her life near here. *Author's collection.*

Amy McGuire, who also remembered Calamity, wrote a tribute to her after she passed on stating, "She was a lover of children and a suppliant for their favor." Occasionally, she would offer children on the street a stick of candy, but oftentimes, their mothers held them back. A few who felt sorry for her let them hold their infant. On occasion, she took the child into the saloon to entertain the men. "Let it be said that the baby was always returned better natured if anything than before she had taken it."[99]

However, Calamity wasn't always so well behaved. An undated incident in Lander involving Calamity solidified Borner's opinion of her. Calamity became very drunk in Lander one day, stripped off her clothes and began singing at the "top of her lungs" while parading up and down Main Street. The authorities arrested her and took her to the Borner residence for her relatives to deal with. John told Calamity to never come back. But she did, just not when Borner was home.[100]

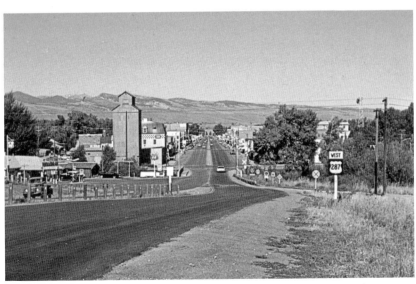

CALAMITY JANE AND HER SIBLINGS

For a number of years, the Union Pacific Railroad facilitated Calamity's thirst for alcohol and adventure. Several budding towns she especially frequented were located along the railroad. They included Cheyenne, Laramie, Rawlins and Green River. The early descriptions of frontier towns at the time wouldn't have been inviting to most women. The settlements were usually bare, brown and desolate, with hardly any beauty to be found. Saloons had the run of the towns. Laws were lax or nonexistent in the early years. Animals rendered the dirt streets filthy and ugly. However, Calamity didn't come for the scenery.

Hoodlums and undesirables moved back and forth among those railroad towns, but Calamity had no fear of the ruffians. She could hold her own and joined them at the bars and participated in their rowdiness. If anyone made fun of her, she pulled out her pistols.

In the 1880s, railroad construction had grown by leaps and bounds. Calamity thrilled at the opportunities. Many towns were connected by other railroads. The Oregon Short Line provided service northwest of Granger into Idaho. The Northern Pacific connected points in northern Wyoming, and the Chicago and North Western jutted from Nebraska to connect Lusk and Douglas.[101] Calamity took advantage of all these options for travel.

Somehow, Calamity gathered enough money for train fare to get her to a new destination, but she didn't always ride in the passenger car. A recollection by a Horr, Montana resident presents a disquieting picture of her. When Calamity hung around the saloons for too long and became an inebriated nuisance, the store delivery wagon picked her up and took her to the depot, where two men swung her up by the leg and arm, one on each side, and heaved her into the baggage car.[102]

Visiting the railroad towns was easy; however, her trek to Lander would have been difficult. No railroads connected with Lander during the period when Calamity made her trips to see her sister and family. The railroad connected to South Pass City from the Union Pacific, but it ended there. It was another thirty-seven miles to Lander from the south. And from the north, the railroad from Riverton to Lander was not established until the twentieth century.

Therefore, it is not surprising that the newspapers do not report a visit from Calamity to Lander when Lena gave birth to daughter Theresa Theodosha in 1880. Instead of journeying to Lander, Calamity Jane spent part of her time that year in Fort Pierre and Rapid City.

The following year, on April 26, 1881, Lena gave birth to another daughter, Johanna Rosanna Julianna, shortened to Hannah. (The Borner

children were often given pet names in addition to their given one.) Calamity may have been at her birth or visited sometime later, as Hannah was the child who mimicked Aunt Calamity's swear words, distressing John Borner to the point that he again told Calamity to never come back.[103]

There was one occasion in Calamity's life where it seemed like she had sowed her wild oats and was ready to settle down and live the life suitable for a woman of her time. Perhaps seeing her sister Lena with a large family had mellowed her a bit. While living on a ranch near Miles City in 1882 with her husband by title, Calamity gave birth to a son whom she named Little Calamity. Calamity Jane assured the newspaper "that she had been entirely regenerated and that during the balance of her days she intended to lead a quiet, domestic, granger life, only visiting town occasionally to hear the band play." Perhaps she was honest in her intent. She had attended the opera earlier in the year while in Bismarck and was recognized as "of the Black Hills notoriety."[104]

However, in the end, Calamity was only deluding herself. Little Calamity died, and she returned to her old ways. In November 1882, she was said to be "doing business at Billings." She had transferred her business to a point farther up the valley, the paper reported. The paper didn't say what kind of business she was running. However, it was something Billings didn't support. "Billings does not regret her loss as any great calamity either."[105]

In December, she was up to her old tricks: "Calamity Jane has gone back on the turf and is running a hurdy-gurdy house at Livingston."[106]

Calamity recalled:

> In 1881 I went to Wyoming and returned in 1882 to Miles City and took up a ranch on the Yellow Stone, raising stock and cattle, also kept a way side inn, where the weary traveler could be accommodated with food, drink, or trouble if he looked for it. Left the ranch in 1883, went to California, going through the States and territories, reached Ogden around the latter part of 1883, and San Francisco in 1884.[107]

She doesn't mention her so-called husband in her autobiography entry, and she's careful not to include the pronoun *we*. It is odd that she hardly ever mentions a traveling companion. The man she lived with on the ranch could have been Frank King, who was probably the father of Little Calamity. She went by the name of Mattie King for a time to give legitimacy to their relationship.[108]

But she flew the coop again. During the winter of 1883, she was in Montana. She and a man named Kibble were arrested at Camas Prairie on

a charge of selling liquor to Indians. Was this yet another man in her life? She and her companion were jailed in Missoula, Montana.[109]

Then, Calamity dusted herself off and continued on to the West Coast. Another railroad was being built, this time through the northwest, providing her another opportunity to share in the thrill and wildness of settlement. She still liked railroad towns, especially in their formative years when they were wide open and wild. She lived in Spokane for a while and dealt faro on Maine Avenue in a wooden building adjacent to the later constructed Owl Saloon. While dealing, it was reported she chewed tobacco and smoked a cigar simultaneously, besides imbibing whiskey with relish. She came when the Northern Pacific was building through and stayed until the excitement died down before joining the Coeur d'Alenes gold rush in Idaho.[110]

Although Calamity said she was in Texas in 1884, the newspapers found her in Idaho and Wyoming. A newspaper article from March 27, 1884, confirmed that Calamity spent March in Idaho. "Calamity Jane, the most noted woman of the western frontier and the heroine of many a thrilling nickel novel, has pulled up stakes and joined the stampede for the Coeur d'Alenes."[111]

Various newspapers reported her trip to Coeur d'Alenes in 1884. A Black Hills newspaper noted her departure and also added, "Poor old Calam has been the most unfortunate woman that ever struck this country…Three years ago she married and settled down on a ranch near Miles City, and has remained there ever since, and is an honored member of the Miles City Society."[112]

A Livingston, Montana newspaper also made note of Calamity taking in the sights of the town in March. Livingston, another town on the Northern Pacific, was another haunt that appealed to Calamity. The newspaper stated, "Jane has been living down the valley for some time but has pulled up stakes and joined the stampede for the Coeur d'Alenes."[113]

However, Calamity experienced competition with another woman of her caliber in the Coeur d'Alenes region. The main rivalry was Molly Burdan, also known as Molly b'Damn. Molly had also read about the gold strike and boarded a train heading for Idaho. Calamity was on the same train and had the same intentions in mind. "When the two ladies met, they decided that Murray wasn't big enough for both of them. Molly possessed something that Calamity did not. Molly was refined and cultured and could quote from Shakespeare, Milton, and Dante. A prospector who met Molly designated her the 'reigning queen of the Murray underworld.' Temporarily defeated, Calamity returned to Deadwood."[114]

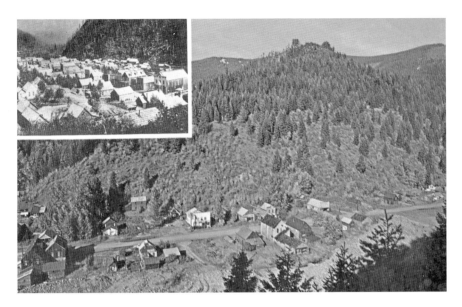

Murray, Idaho, was a gold rush town in Idaho. Murray grew to become the county seat in 1885. *Author's collection.*

A month later, after Calamity had made plans to favor Murray with her presence, she was back in Livingston, Montana. "Jane has successfully escaped various trials and tribulations incident to a trip to the Coeur d'Alenes and is back in Livingston again. She has had enough of the mines and abused that country in round terms. Jane has had a life's experiences in western camps, and is able to size up a new country pretty intelligently."[115]

Calamity may not have laid claim to Murray, but she had frequented Eagle City, a short-lived boomtown, on her first trip to the Coeur d'Alenes. She would have been quite at home in the town, which began as a tent city in 1883. Most of its population arrived a year later, but by August, the population had moved on.[116]

Apparently, it was no easy task to get to Eagle City. Calamity, accompanied by an entourage of eight girls, struggled by horseback over the rugged Jackass Trail, which sits atop the Continental Divide in the Wind River Mountain Range. The view was spectacular, but it's doubtful the girls noticed. Even trying for a jackass, the steep, granite inclines would have challenged the best of horses, as well as the female riders, including the rough and tough Calamity.

The folks living in the area of Eagle City remember dancing and partying with Calamity Jane during the Coeur d'Alenes gold rush. A newspaper reported on the first big social event in the Eagle City–Murray district north

of Wallace in 1884. Calamity and her girls took over a tented barroom and performed. Adam Aulbach, editor of a local newspaper, wrote, "As red calico stage curtains parted, in her mannish woolens, she did a monologue of her life. The girls, more feminine, danced and the party was on." Each man was given a choice of the ladies and a turn around the dance floor. Fights ensued, but the next morning, Calamity wrapped up the profits.[117]

After Calamity's return, she didn't let any grass grow under her feet or any opportunity escape her. In 1884, the *Billings Post* of Montana reported that Calamity Jane left on Monday's train to join the Liver-Eating Johnson Troupe. The paper also noted that she wasn't as attractive in appearance as in Deadwood's early days.[118]

The *Billings Post* reported, "The erratic female, known as Calamity Jane, who was one of the first stampeders into the Black Hills Country left on Monday's train to join the Liver-Eating Johnson Troupe."[119]

During the 1880s, Wild West shows were the main attractions of western entertainment. Bringing back the days of the Old West, these open-air touring performances, such as those mastered by Buffalo Bill Cody, Pawnee Bill and Doc Carver, were popular. Liver-Eating Johnson was the sobriquet for John Johnson, one of Tom Hardwick and William Skeigle's Great Rocky Mountain Show attractions. John Johnson received his moniker from supposedly eating the livers of the Crow Indians he killed after they murdered his family. He was joined in the show by former western army scouts; Crow Indians; Curley, the purported survivor of the Battle of the Little Big Horn; and Calamity Jane. After a few months, financial troubles ended the show. The members were forced to sell their ponies in order to get back to Montana.[120]

As newsy as the experience would have been, Calamity doesn't mention her performances in her autobiography. Instead, she recorded:

> *Left San Francisco in the summer of 1884 for Texas, stopping at Fort Yuma, Arizona, the hottest spot in the United States. Stopping at all points of interest until I reached El Paso in the fall. While in El Paso, I met Mr. Clinton Burk, a native of Texas, who I married in August of 1885. As I thought I had traveled through life long enough alone and thought it was about time to take a partner for the rest of my days.*[121]

Calamity didn't meet Clinton Burke on the dates she mentioned. She misled her readers once again. She spent 1885 in Wyoming and visited Lander from time to time, even living there for a spell.

The Episcopal Mission is shown on the Wind River Indian Reservation, Fort Washakie. Photographer Jack E. Boucher. *Library of Congress, Prints and Photographs Division, HABS WYO, 7-FOWA v, 2-1.*

During November 1884, Calamity was in Wyoming and was reported to have been "leading a quiet life at Fort Washakie." Since she was in the vicinity of Lander when she was residing in Fort Washakie, perhaps she made a visit to Lena and her new niece Bertha (Bertie Pauline), born in September 1884.[122]

But in her inimitable style, she didn't stay long. In December, she was back in Rawlins. "Calamity Jane the noted and notorious…is in Rawlins," a Wyoming newspaper reported. Calamity would rally back and forth among the various Wyoming towns for the next ten years, most often wearing out her welcome wherever she went. But for now, she was staying close to Lander.[123]

Calamity spent a great deal of time in Lander during 1885, in between visits to Rawlins. Calamity was in Lander in March. A Livingston newspaper uncharitably announced, "Calamity Jane, who infested the Yellowstone Valley a few years ago, is said to be disporting herself among the residents of Lander Wyoming."[124]

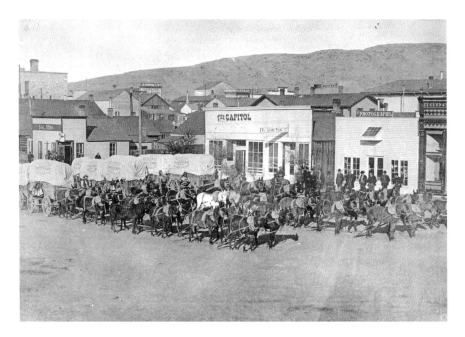

This mule freight train, which delivered goods to Lander and Fort Washakie, made a stop in Rawlins, another favorite haunt of Calamity. *Author's collection.*

Her nephew William Frederick was born on April 27, 1885. Perhaps she visited Lena and the new baby when John Borner wasn't home.

While in Lander, Calamity was profiled in "A Sketch of the Reckless Life of This Female Bandit." The newspaper reported, "A correspondent of the *Cheyenne Leader*, writing from Lander, Wyo., under date of Oct 30th, gives the following account of a peculiar character whose history begins in Uinta County." The sketch described her: "She owned the heart of a tigress. Reckless in disposition, pretty in looks, and full of animal spirits, she had lovers by the crowd." The interview began with her early life when she was in the company of the Gallaghers in Miner's Delight in 1868 and concluded with her supposed association with the Bevan's gang. According to the interview, Calamity supposedly laid the plan for a daring stage coach robbery in 1877; however, she was never proven to have been involved.[125]

A Bismarck newspaper also confirmed her presence in Lander. The November 1885 issue bluntly and aptly reported that Calamity Jane was "terrorizing Lander City at present."[126]

During the fall and winter of 1885, Calamity traveled between Lander and Rawlins. Wyoming newspapers reported that she was in Rawlins in the earlier part of November. "Calamity is here, but she came on the coach, she may

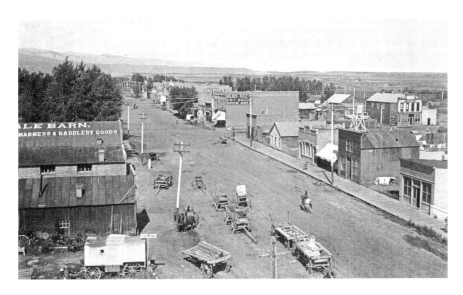

This frontier scene photograph was taken in Lander, Wyoming, in 1906. Calamity visited here from time to time and maybe even worked in Lena's laundry. *Author's collection.*

be found in a neat little, rough board one-room residence on Slaughterhouse street." One week later, she was reported to have settled in Lander.[127]

The next year, Calamity found herself among the society notes in the Rawlins newspaper in July 1886. "It is the proper thing to remark that Calamity Jane has been painting the town in her usual lurid style during the week. She dropped in from Idaho."[128]

At some point, Calamity hooked up with Bill Steers, who was nine years younger and possessed an abusive disposition toward her. They may have met in Rawlins and traveled together to Meeker, Colorado. Several years before, the Colorado White River Indian Agency experienced a Ute uprising in 1879 and the Ute war in 1880. Legislation moved the Ute to reservations. A garrison was established, called Camp at White River, on the future town site of Meeker, which was established in 1883 after the troops left.[129]

According to a Meeker-area resident, the couple lived together for two months or better. But in September, Calamity swore out a warrant for Steer's arrest. He had tried to harm her with a knife handle and used a rock to hit her on the lip. Steers was jailed, and after the trial, he and Calamity became drunk. However, afterward, she apparently forgave him, and they left Meeker, Colorado, together.[130]

The fall of 1886 was most unpleasant for Calamity. She frequented Rawlins once again in September for several days after the trial. The newspaper

announced she was in town. She was using the name Mrs. Mattie King at the post office, the newspaper explained. Feeling sorry for her difficulties, the Rawlins newspaper generously defended her character. "Calamity is not half as bad as the human ghouls that abuse her. The victim of passion, with generous impulses, this poor pilgrim has been made the scapegoat of the outlaw, the assassin, the tinhorn, and at last the outcast of man." Another Rawlins newspaper added to the story by exclaiming that Steers deserved "a hangman's knot."[131]

The next month, Calamity was in the county jail in Rawlins. She and Steers had gotten into another fight. Steers, whom the reporter described as "one of the most worthless curs unhung," had taken a wrench and hit Calamity over the head and left a large gash. When Calamity didn't draw the sympathy she thought she deserved from the next-door saloon, she threw rocks through its large glass window. Steers fled and Calamity was tossed in jail.[132]

Steers didn't run far. He was caught and thrown in jail for thirty days for taking a wrench to Calamity, the Rawlins newspaper reported, and then opined it was time he received the punishment he deserved. "He is a miserable stick and deserves a more severe punishment than a month's free board, but the law will not allow it."[133]

In March 1887, Calamity Jane was in Cheyenne after an absence of ten or eleven years. Those who had seen her said she appeared in a very dilapidated condition. No doubt, Bill Steers hadn't helped matters. The paper went on to say she had led a very checkered career, appearing in many towns throughout the west, including Deadwood and Cheyenne. While in Cheyenne, the *Cheyenne Leader* interviewed Calamity Jane on a July day in 1887. As usual she exaggerated and changed her life's story to suit her whim, placing herself in the midst of daring events that she had probably only heard about. She told the paper that she was born of poor parents at Fort Washakie and was "adopted into the family of an officer stationed there, but ran away and entered upon a 'sporting' life at the age of thirteen years."[134]

She continued the interview with outlandish tales of Cheyenne, Lander and Rawlins where she was the center of attention. In Bismarck, she claimed, a couple of army officers fought "on her account." One of them was killed, and she had to leave town to escape the lynchers. After a few more escapades, she went to Lander, and in less than twenty-four hours, "a drunken cowboy had killed a store keeper on her account." She said she was sorry "but could not help it."[135]

The article concluded with the announcement that Calamity had married Mr. Steers two years ago, living reasonably quiet except for her sprees.[136]

Actually, she wasn't yet married to Steers, and they probably met in 1886 rather than 1885.

The next month, in August 1887, Calamity was reported to be in Lander. "The only and original Calamity Jane is now in Lander, and is improving Lander influence by leading a strictly, industrious and happy life."[137] Calamity may have been behaving herself because she was expecting a baby. Unfortunately, Steers was still in her life.

The September 2, 1887 *Cheyenne* edition announced, "Wm. P. Steers is the husband of the famous Calamity Jane. The pair now resides at Lander, Fremont County." In fact, the couple would not be married until May 30, 1888, in Pocatello, but Calamity pretended they were anyway. Her baby, Jessie, needed a father.[138] It is ironic that she would be worried about legitimacy.

Now where was Clinton Burke, whom she supposedly married in 1885, according to her autobiography? She again confuses the reader with incorrect dates. She hadn't met Burke yet. She would meet him sometime in the 1890s. Calamity purposely misled the readers many times when she narrated her autobiography. She conveniently edited Steers from her life and replaced him with Clinton Burke, whom she met after Steers. She may have wanted to erase Steers from her life, for theirs was not a happy marriage nor was he an ideal father.

A month later, the *Sundance Gazette* announced prematurely that William P. Steers was the husband of the famous Calamity Jane. The pair was now residing in Lander, Fremont County. "Steers recently wrote a letter to a friend in this city in which he states has succeeded in 'getting away with the old woman's watch and chain.' Steers and Calamity separate about four times every year, and as often reunite. The dime novel heroine's husband is a lightly built, sickly looking and unassuming genius, about 25 years old. He was born in the backwoods of Wisconsin."[139]

Calamity stated in her autobiography that she and her supposed husband Clinton Burke were in Texas until 1889.

> We remained in Texas leading a quiet home life until 1889. On October 28th, 1887, I became the mother of a girl baby, the very image of its father, at least that is what he said, but who has the temper of its mother.[140]

Calamity leads us to believe that Clinton Burke was the baby's father, when in actuality it was probably Bill Steers who was the father. The baby girl was possibly born in Lander. Was Lena there to assist her sister during birth?

CALAMITY JANE AND HER SIBLINGS

The Borner cabin in Greybull, Wyoming, is pictured with an unidentified woman in the doorway. *Wyoming State Archives, Department of State Parks and Cultural Resources, Kennedy Collection #90.*

Meanwhile, Lena and John were becoming discouraged with their neighbors over irrigation ditches. In contrast to Calamity, Lena had led a quiet life married to John G. Borner, living outside Lander, Wyoming. The surrounding land was desert-like, but by using irrigation ditches, John raised remarkable crops, which he took to Lander to sell. The area, which he farmed, became well known throughout the region as Borner's Gardens.

But in spite of their successes in the Lander area, Borner began to look elsewhere for a place to live. In the spring of 1886, Borner explored the Big Horn Basin to the north, where he found bottomland below the mouth of the Greybull River. He filed on this land and built a small log cabin, with a lime rock fireplace, near the west bank of the Big Horn River. Later, Borner filed on three sections of land under the laws at that time.[141]

Unlike her sister, Lena was not possessed by wanderlust, nor did her name appear in the newspapers often. She raised seven children and helped with the ranch, leaving her little time for outside endeavors.

Conversely, Calamity Jane continued to be a heroine in the fictional world of published pulp fiction, especially from the pen of Edward Wheeler. His dime novels began portraying her as early as 1877. Very little of what

58

was written actually portrayed the real woman, but the stories she inspired pleased the buying public and assisted her rise to fame. One of the reasons for her popularity may have been that she chose not to live according to societal expectations.

In January 1888, Street and Smith of the *New York Weekly* placed an ad announcing a story entitled *Calamity Jane, The Queen of the Plains: A Tale of Daring Deeds by a Brave Woman's Hands*. The story was advertised as being from the pen of contributor Reckless Ralph, who was a great trapper and hunter and lived among the scenes he describes. The first chapters were to appear in serial form in issue ten of the *New York Weekly*. Subscription prices were given to receive the thrilling adventures of road agents, gold diggers and desperadoes.[142]

Calamity was continuing to have trouble with Bill Steers, but Lena was having difficulties of her own of another nature. On February 23, 1888, the *Freemont Clipper* reported trouble over an irrigation ditch. The commissioners turned the Borner-Hornecker-Nicol ditch case over to C.B. Harrison, P.P. Dickinson and C.W. Crowley as appraisers. They were to assess the damages to the landowners, Hornecker and Nicol. Lena Borner had constructed a ditch over their premises with the intention of reclaiming eighty-nine acres of desert land. "The ditch, when completed, will be about three miles in length and will be quite expensive. One flume will be over 1,000 feet long, besides several smaller ones which in the aggregate will require several thousand feet of lumber and cost not less than $800, which is ten dollars per acre."[143]

Putting friendships aside, the Hornecker involved in the dispute was Ernest Hornecker's brother J.M. (Mart). His place was just above Ernest's. Like his neighbors, J.M. Hornecker depended on irrigation ditches to bring the dry land of Lander to life. The river ran full of water, which the farmers diverted using ditches to water their crops.

The dispute continued, and in March 1888, the *Freemont Clipper* reported, "The damage assessed against Mrs. Lena Borner on account of the ditch was placed at $114, which the aggrieved parties refuse to accept. Mrs. Borner will proceed with the ditch pending further litigation." John Borner was probably away at this time establishing a homestead for his family on the present site of Greybull, Wyoming. He was building up the homestead near the Greybull River and Shell Creek.[144]

In June, Borner had completed his ditch. When he was ready to let the water in, he disovered that someone had cut it where it passed through J.M. Hornecker's farm "and at a point where the latter's ditch crosses it."

Borner proceeded with an injunction to prevent further interference, and he commenced action against Hornecker for destruction of property.[145]

In addition to the water problem, tragedy struck the Borner family in October. Several years before, while John was in Billings on his annual trip for supplies, Lena and the family were left to do the chores. When Lena was feeding a calf tied to a post with a rope, she became tangled in the rope, fell down and injured her hip, which caused an abscess that she never fully recovered from. Her death devastated not only her family but the community as well.

Lena's obituary appeared in the newspapers. It read:

> *At Rest. Late on Saturday, when twilight shadows began to veil the quiet earth, Lena, the beloved wife of John G. Borner, closed her eyes on the misty sights of earth and sank into the dreamless sleep of eternity. Her death is a sad blow to her husband, and the entire community gives him its full sympathy in his deep affliction. Seven little children, the oldest but ten years of age, are left to his care and guidance. Mrs. Borner had been in ill health for some time, and never recovered from an accident that befell her two years ago. She was one of the most industrious women in the valley and one whom all her acquaintances held in the highest respect. Her pride was in her children and her home and her hands were ever busy with the work they found to do. All that medical skill could accomplish was done for her, but the unrelenting shadow of death had settled upon her, and her system, worn down by patient toil and cares, gave way beneath the unequal strain. Her funeral, which was largely attended took place yesterday, Rev. Frank M. Day officiating, the burial occurring in the Masonic cemetery at North Fork. J.I. Patten, E.F. Cheney, Chas. E. Fogg, F.G. Burnett, Charley Allen, and Samuel Sparhawk were the pall bearers. Undertaker Firestone had charge of the ceremony.[146]*

Where was Martha during all the turmoil? She was still having troubles of her own with George Steers. In April 1888, the *Big Horn Sentinel* of Buffalo reported that Calamity had her "so-called husband arrested for assault and thrown in jail at Green River." Later, Calamity was also arrested for being drunk and disorderly and "now occupies quarters in the county bastile." About one week later, the *Sundance Gazette* substantiated the report, adding, "That noted character 'Calamity Jane' was given four hours at Green River, Wyoming to rustle a fine or leave town. She skipped."[147]

Apparently the tussles with her man didn't deter her from marrying him. On May 30, 1888, she traveled to Pocatello, Idaho, and married Steers, but

Sagebrush creeps into the border of the Milford Cemetery, where Lena Canary Borner was buried. No record was kept of the plot location. *Author's collection.*

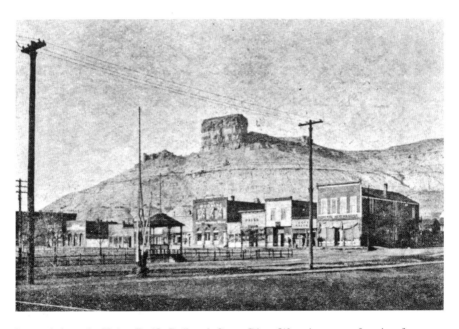

Located along the Union Pacific Railroad, Green River, Wyoming, was a favorite of Calamity Jane. *Author's collection.*

the sun wouldn't shine on their marriage. Calamity probably chose Pocatello for added excitement as it was a wide-open railroad town. The witnesses were Lizzie Bard and Charles Brown.[148]

Calamity Jane spent New Year's in Wendover, Wyoming, in 1889, apparently over celebrating the holidays. The *Cheyenne Weekly Sun* reported, "Calamity is the most amiable of women; ornery of feature though kindly of eye, and an enthusiastic bull on the whiskey market…As a female holy terror she has no living superior, and her worst enemies will not deny that she is an able drinker."[149]

Surprisingly, in June 1889, Calamity Jane and Bill Steers were in Oakland, California, according to a San Francisco newspaper. A man by the name of A.C. Warren brought a suit against Martha Steers, who was living on Market Street and caring for the man's child. Martha's husband, who admitted that he had been in jail several times and was living off the fallen woman's proceeds, aided him in the suit. Steers's reputation preceded him, and the newspaper was quick to defend Calamity. She "has been compelled to support him and endure his cruelty," the newspaper wrote.[150]

After a fight with Martha, Steers had written a letter to Warren stating that Martha was an unfit mother because she was a drunkard. By writing the letter, Steers had betrayed his wife. Being concerned for the child's welfare, Warren came to Oakland.[151]

According to the newspaper, Warren had given the child to Martha Steers when she and her husband, Bill Steers, were in Tacoma a year before. The Steerses had pitched a tent next to Warren and his children while there. Warren's wife had left him with three children, and since he wasn't able to care for them, he gave two boys to Martha, who had expressed concern over their well being. At some point, Warren had stolen the younger boy back but now was pressing charges that Martha was keeping the eight-year-old boy against his will.[152]

Acknowledging that Martha Steers was Calamity Jane, the newspaper described her as "a degraded woman with bleary eyes and a dangerous breath." Poor Calamity didn't have a chance after she was discovered by the sheriff lying in a yard "beastly drunk" with the child in her arms before the trial.[153]

The courtroom was moved to tears when the judge gave Warren, the father, custody of the child and took him out of the courtroom, in spite of Martha's pleas to keep him, promising to love him and keep him from harm.[154]

Calamity was in such a state of despair that the judge suggested that she be placed under the charge of the Association of Charities. It's doubtful Calamity accepted the recommendation.[155]

No mention was made of Jessie, the Steerses' daughter, who would have been two years old. Calamity may have left her with someone, as she sometimes did.[156]

It is probable that Calamity obtained a divorce from Steers around that time. A strange snippet of information appeared in the Livingston newspaper, alluding to a divorce she obtained from her second husband in "Almeda, California." The "Almeda" mentioned was probably Alameda County, where Oakland and San Francisco are located. Unfortunately, there is no official divorce record located in Alameda County or any mention of the court case, but the newspaper continued with a garbled account. Calamity supposedly said:

> *"I'm a rough woman, jedge," she said, "but these kids allus have had a square deal from me, I ain't no saint, and yet I might be worse; I've nursed this man that's gettin' this divorce, and I've saved his worthless life once; the law ain't givin' me a square deal—it never gives a woman a square deal, nohow."*[157]

The children she mentions caring for undoubtedly were those of A.C. Warren's, in addition to her own daughter, Jessie.

The newspaper was confused when it stated that the worthless husband received the custody of her offspring. It was A.C. Warren who received custody of his children, whom he supposedly gave to Calamity to care for at an earlier date.

Surprisingly, Calamity expresses her discontent with a woman's lot in life when she supposedly said in court, "it never gives a woman a square deal, nohow." She had forged ahead on her own ever since she was orphaned, trying her best to make her way in the world. Without a husband for support, a woman had few options to earn a living in the West. Calamity had tried them all, even dressing like a man to land a job. But she was usually discovered to be a woman, so she tried to earn a living as a woman, which left fewer options. She attempted them all, from being an occasional prostitute to being a cook, a laundress or a cleaning lady. Her forte was dancing, however. She danced in a hurdy-gurdy hall to earn a few pennies. Her legendary status propelled her forward, and she became an attraction in several museums. But in the end, she was selling a pamphlet of her life story, along with her photographs. It was never easy for her.

It was probably after this court incident that William Steers and Calamity parted ways. Calamity went back to Wyoming, and Steers may have

remained in California. He lived in California for forty-five years, dying at the age of sixty-seven in 1933.[158]

Calamity apparently returned to Wyoming from California, for she was seen in several different towns throughout the area. She was in Cheyenne in January 1890, arriving from Casper, Wyoming. The paper charitably christened her as "the uncrowned queen of a thousand frontier towns and mining camps and who is the heroine of numerous sensational publications." No mention was made of her daughter, Jessie.[159]

She was "fired out of Cheyenne" four or five days later. She then went to Laramie on the evening train but kept herself away from public attention.[160]

Calamity Jane moved on to Rock Springs in June 1890, using the name Jane Steers. Nine new coal mines had opened in Rock Springs in 1890, bringing in a rowdy crowd of miners and saloons, enough entertainment for Calamity, for a while anyway.[161]

Calamity had apparently been spending time in Lander, too, for she stopped in Omaha in February 1892 on her way home from a trip to Iowa to visit relatives, perhaps her mother's family. She told reporters she resided in Lander. She may have been there in 1891, too, since it was a quiet year for her in the newspapers.[162]

In December 1893, she was in Green River for a short time. She was using the name Mrs. King, indicating that Bill Steers was history and maybe Mr. King was back in her life. She had also moved to Billings, where she was reported to be living with her husband, Clinton Burke, and daughter.[163]

5

THE BORNERS

After Lena's death in October 1888, John Borner, brokenhearted over losing his wife and weary of fighting with his neighbors, sold his land near Lander to the State Poor Farm in 1888–89.

He waited until spring, loaded his seven children in one covered wagon and household goods in another and trailed one hundred head of cattle and about twenty head of horses to their new home in the Big Horn Basin. They arrived on May 16, just before a spring blizzard. The log cabin that he had built earlier was waiting for them. Borner had brought along lumber to finish the floor.

When the weather improved, he cleared ten acres for farming and dug a cellar lined with lime rock as protection against Indian raids. Food and water were kept in it at all times, although the cellar was never needed. He instructed his children to stay in the cellar when he went to Billings for supplies, which was usually twice a year. He would usually be gone several weeks, but the children didn't heed his instructions. As soon as he left, they popped out of the underground hideout.[164]

A daughter, Bertha Pauline, was seven at the time of the move and remembered the ride. The four mules that pulled the wagon didn't need any driving, she recalled, so the children sat in the wagon with a box of crackers and a jug of syrup. They dipped the crackers in syrup and ate all the way to their new home. As suspected, they "were smeared from one end to the other."[165]

Credited as establishing the town of Lander and also being Greybull's first citizen, Borner had unknowingly, along with his hired man J.A. Benjamin,

The Bighorn River provided water a short distance from the Borner cabin in Greybull, Wyoming. *Author's collection.*

The Borner cabin as it stood in the Greybull, Wyoming city park. *Author's collection.*

built his new cabin on what would later become Greybull's city park, but at the time, he didn't know he had founded a town. He had, in fact, homesteaded all the land where the main part of the town is located.[166]

He hired J.L. Denney to teach school in the Borner home for three months while he worked diligently to bring water to his ranch such as he had done at Lander. He built ditches to bring in the precious water for his crops but experienced many failures until, at last, he built a somewhat successful ditch in 1893, which tapped Dry Creek—its name indicated its dependability.[167]

Borner never remarried but endured the work and the hardships alone until his children could be of assistance. Borner suffered from the debilities he acquired during the Civil War. Unable to shake them entirely, he suffered the rest of his life, to the point that he was unable to work on occasion. But he managed to raise his children to adulthood. The Borners were apparently a close-knit family. Irvin Wilkinson, a son-in-law, noted that John loved his children and they loved him. After working on his ranch all day, he placed buffalo robes on the floor and played with them.[168]

The Borner family wasn't immune to family problems. Borner would realize that Calamity and Elijah weren't the only ones who dabbled in high adventure. In 1900, alarming headlines appeared in the newspapers concerning his son Tobias Borner. Trouble was brewing in the Borner family. Three cowboys, John and Albert (Herbert) Alderdice and Tobias Borner, demonstrated their hostilities toward one another. The newspaper reported that the three

> engaged in a shooting affray in the mountains near Otto, Wyoming last Thursday. Three horses were killed and the Alderdice brothers, were seriously wounded. John received a ball in each arm and Albert [Herbert] was shot in the stomach. It is alleged that the two families have been at war for some time and further trouble will probably ensue.[169]

The Alderdices were in-laws of the Borners. Samuel Herbert Alderdice had married Tobias's sister Hannah in Casper, Wyoming, on March 17, 1900. Even though Samuel Herbert was Tobias's brother-in-law, they were not on friendly terms. The Alderdice family had been one of the first families in the Greybull area, but for some reason, some family members had developed an animosity toward one another.

The *Sheridan Post* reported more detail on the affray by acknowledging that there had been bad blood between these gentlemen for some time. It was no surprise that serious trouble would result. They met on the road, and the

Alderdice boys began shooting at Tobe Borner, whose team at once started to run.

> *By the time Borner succeeded in stopping his team the other boys were out of ammunition and did not want to continue the fight. Borner then commenced to shoot and killed one horse and wounded the other, and shot John Alderdice through both arms, the ball entering the right arm and passing out through the left arm. Further trouble is now looked for between those parties.* [170]

The *Sheridan Post*'s prediction came into play the next year. The headline read, "Duelists Held for Trial." The article stated:

> *Tobias Borner has been arrested on the charge of assault with intent to kill, and at his preliminary hearing was bound over to the district court. The complaining witnesses are Herbert and John Alderdice. The three men met on the train near Basin one day in January and fought a duel. The Alderdice brothers were wounded and Borner escaped unhurt.* [171]

When Tobias died on July 13, 1950, at the age of seventy-three, the newspaper headline read, "Nephew of Famed Calamity Jane Dies." If he had contact with his aunt in later life, it is not clear, but Tobias began freighting between Billings, Montana, and Lander at the age of twenty. He may have seen her on one of his trips. He later moved to Shell, Wyoming, where he was connected with the Shell Creek Cattle association. He was later employed by the government as a forest ranger and government hunter. Tobias also wrote pioneer stories for the *Thermopolis Independent* newspaper. His byline was "Tobe Borner, Pioneer Cowboy." He died in a Billings, Montana hospital as the result of a stroke suffered on the Fourth of July. [172]

During the early 1900s, John G. Borner's name begins to appear in the newspapers for different reasons than his son and in-laws. Borner's name was connected with his Grand Army of the Republic (GAR) membership, having been a mason in Utah even before he settled in Wyoming. He was prominent in Masonic affairs and was Master of Temple Lodge No. 20, A.F. and A.M. (Ancient Free and Accepted Masons) of Basin, for the years 1906–7. In addition, the community-minded John Borner joined the County Fair Association in 1906, which met to make arrangements for organizing a fair, and in 1909, he was post chaplain. [173]

Pioneer John Borner is credited for founding the town of Greybull, Wyoming. *Author's collection.*

In 1915, John Borner celebrated his eightieth birthday, but he still continued his service to the GAR and helped organize Memorial Day exercises, which were well attended. The newspaper faithfully reported, "A large crowd present to do honor to the old soldiers living and their comrades whose graves are found on countless hills and in as many dales. The exercises were enjoyed by all present, an excellent program having been prepared by the members of the...G.A.R. These exercises were conducted by Commander John Borner."[174]

When Borner died on December 13, 1919, of cerebral hemorrhage, he had the distinction of being the oldest Mason in the state, having been a member for fifty-nine years. Much loved by the community, the newspaper wrote a lengthy obituary commemorating the first citizen of Greybull, Uncle Johnny Borner.

> *A lull of quiet came over the usually busy and noisy bustle of Greybull Avenue Thursday afternoon, as the members of the Masonic Lodge No. 34 of this city stood with bared heads in two lines, while the remains of John G. Borner were placed in the hearse at Cassell's undertaking parlors, from which place the Masons marched in body to the Baptist church, where services were conducted by Rev. Dean Watkins of the Episcopal church at*

The cabin's stone and earth fireplace was left standing. The city fenced it off to commemorate the first homestead along the Big Horn River. *Author's collection.*

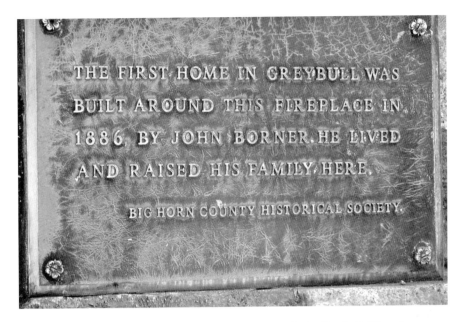

A Borner cabin plaque commemorates the early home site in Greybull, Wyoming. *Author's collection.*

Basin. Mr. Borner passed to the great beyond last Saturday, at the ripe old age of 84 years, 11 months and 9 days. Since the first days of our city he has been one of its best citizens, honest, industrious, faithful, and generous. He was even here before a city was ever platted, and homesteaded the land on which our flourishing city now stands. His homestead shack which he originally lived in still stands down by the Big Horn river, built after the style of most homestead shacks in the pioneer days of Wyoming, of logs. Coming here in early days, he lived to see Greybull's level, expanse transform from a stretch of sage brush into one of the liveliest cities of the state.

The newspaper went on to say that John Borner was survived by his seven children and thirty-nine grandchildren. He was interred at the Greybull cemetery.[175]

The cabin that Borner built in Greybull lasted for one hundred years, but it collapsed from heavy snows in February 1960. The town had been discussing tearing it down before rot and snow did the job for them.[176] The fireplace was left as a testament to John and Lena Borner's legacy.

6

ELIJAH

U nfortunately, segments of Elijah's life before and after his residence
with the Borners are buried in mystery. Information about his parents,
his family life and even his own birth is mired in contradictions. After piecing
together his life from newspapers, reminiscences and legal documents,
a pattern evolves as to where and how he lived. Even a glimpse of his
personality emerges.

Elijah probably lived for a time in Lander after John and Lena were
married. Whether he lived with the newlyweds is not clear, but he may have
also worked in the laundry business Borner established in a log cabin between
Second and Third Streets for Lena and Calamity Jane to run. Lena operated
the business for about ten years. Lena and Elijah may have run the business
together, as Calamity was always on the move and not dependable.[177]

Regrettably, Tobias Borner didn't mention how long Elijah worked for
Borner, what he did, where he went after leaving the Borner family or whether
he departed on good terms with John Borner. He left before the 1880 census,
as he was not recorded as living with Lena, John or the children (Mabel, Tobias
and Francis). In either case, Elijah was on his own at a young age.[178]

During the course of his life, Elijah met many individuals who could
have been positive and stable influences if he had given up his passion and
obsession with horses, but he chose not to live by their example. Instead,
he preferred riding roughshod throughout the plains and mountains of
Wyoming, Utah and Idaho during the tumultuous years when Wyoming
and the neighboring states were desperate to rid their region of outlaw

The Popo Agie River flows through Lander, Wyoming. The river supplied water for Lena's laundry. *Author's collection.*

harassment. From the late 1880s into the new century, Elijah continued to be a bur under the sheriff's saddle. The "rough and tumble boy" that he was when he worked for the Borner family has seemed to remain a part of his character throughout his life.

Perhaps being orphaned at a young age and the area and time in which he lived contributed to his wayward life. Opportunities were limited for laborers in the late 1880s; transient workers inundated the towns during this period looking for work.[179] Perhaps he was influenced by his "wild cat" sister, Calamity Jane, or the errant characters he met along the way. Someone else had effected his behavior more than the admirable role models.

The newspapers offer the most information on Elijah, and they reported on him at his worst. If he had any redeeming qualities, they, unfortunately, are left to imagination, although his cousins believed that in his final years he was a kindly old gent. But up until that time, he led a wild and rugged life. Elijah disappears from the pages of history for nearly two decades, unlike his sister Calamity, who was often in the limelight.[180]

Correspondent MyFanwy Thomas Goodnough reported in the *Wyoming State Tribune* November 2, 1893 issue that two of Calamity Jane's brothers lived in the Star Valley in the village of Freedom. Elijah may have lived in Freedom, but he had no other brother beside Cilus, who had died when he was a small boy.[181] Nevertheless, Star Valley would play an important part in Elijah's life.

In 1879, Latter-day Saints from St. Charles, Idaho, founded the town of Freedom as a haven for polygamists. The community of Freedom straddles the boundary line between Wyoming and Idaho. It possesses the distinction of being the only town in the United States to be within two states and three counties. The main street that runs north and south through the center of town is the state line. Fugitives were able move across state lines rather easily to avoid the arms of the law, hence the name Freedom. Since Congress outlawed polygamy in 1887, Mormons practicing polygamy and fugitive outlaws used the entire region of Star Valley as a hideaway conveniently surrounded by mountains. The fact that Elijah settled in the Star Valley area, located south of Jackson, Wyoming, is suggestive of illegal activity. He could have been in hiding from something or someone.

Not only was Star Valley a haven for polygamists, but it also became a refuge for outlaws like Butch Cassidy, Mat Warner, Tom McCarty, Elzy Lay, Al Hainer, Bub Meeks and other outlaws. The topography and heavy winter snows created a safe place in Star Valley. The outlaws made themselves at home, becoming a regular part of the community.[182]

THE SAGA OF LENA AND ELIJAH CANARY

The little rock Auburn church built in 1889 is an example of their camaraderie with the local people. The church was the center of social and religious activity, and when a dance was held there, the outlaws often attended. "The dance hall was usually so crowded the dance tickets were numbered and just one third of those attending could dance at a time. Some of the young men bought a number of tickets so they could get in more dances."[183] Citizens tolerated these outlaws if they behaved themselves and didn't bother the local people.

If the Goodnough newspaper article is correct and Elijah lived in Freedom, he probably had connections with outlaws who lived in the valley. Elijah could even have attended the dances at the stone church in Auburn and learned about their horse stealing operations, perpetrated within the region during the 1800s. Apparently, at some time in his life, Elijah was enticed into horse stealing.

Opportunities for becoming a horse thief abounded in western Wyoming. An 1885 issue of the *Uinta Chieftain* reprinted a plea for help originally printed in the *Cheyenne Tribune*:

> *Would it not be well for the authorities of the United States and of the territory to give a little more attention to the life and property of bona fide residents from the operations of murderers and thieves. Reports come daily of depredations of outlaws in the northwestern portion of the territory. Late reports from the northwestern portion of the Teton country, places the number of horse thieves and desperadoes who make that region their head quarters at from sixty or seventy.*[184]

One example of a safe haven for outlaws was the Teton Basin, to the north of Star Valley. Surrounded by the Rocky Mountains, the Teton Basin, with only two passes for entrance, provided an impregnable refuge, especially during the winter months, when the passes would fill with deep snow, wrapping the outlaws and horses in perfect seclusion. A well-built log cabin in the basin added further security from approaching law enforcement, "which could be held against almost anything, but artillery."[185]

The basin extended for about twenty square miles where the bands of stolen horses were brought into the extensive, well-watered meadowlands. The bunch grass provided nourishment to fatten the horses during the winter when raiding subsided. When the last of the purloined horses were herded into the valley, the brands were reworked by "applying the red bottom of a frying pan to the brands necessary to be obliterated." The area burned in

this manner was saturated with grease, which caused the hair to grow in the spring time, removing every trace of the brand. Experts with the branding iron placed additional markings on the animal to make it impossible for an owner to recognize his brand. "After the job was done, the bandits hunted, gambled and drank whiskey, joined in shooting matches and horse racing to pass the winter days. In May the horses were rounded up, divided up into small bands, sleek and fat, and then were taken slowly in different directions to various points and disposed of."[186]

Gangs of horse thieves stole choice horses from Idaho and eventually sold them throughout Wyoming. In turn, they stole horses from Wyoming and sold them in Idaho. Stolen stock was also driven to Montana and Dakota. The plan worked well for a period of years. Elijah could have easily hooked up with this band of thieves—or any other band, for that matter—and learned the trade.

Almost twenty years elapses before information on Elijah appears. On June 15, 1894, prosecuting attorney John C. Hamm, representing the State of Wyoming, County of Uinta, informed the court that "Cannary a fugitive from Justice…unlawfully, feloniously, willfully and maliciously on the track of the Oregon Short Line Railroad in said county, by placing thereon horses and livestock, did place obstructions so as to endanger the passing of trains thereon." The same legal jargon was also recorded for his partner Oliff Helquist, alias J.B. Johnson, who was also charged with the crime.[187]

Star Valley, where Elijah was probably living at the time, was located north of Uinta County, Wyoming. Today, Evanston is the county seat of Uinta County. The Oregon Short Line, which Elijah and his accomplices targeted, was organized in 1881 as a subsidiary of the Union Pacific Railroad, providing a shorter route from Wyoming to Oregon.

Elijah should have known better than to mess with the Union Pacific Railroad. For how long Elijah had been stealing horses and tempting fate is uncertain. Unfortunately, Elijah's arrest not only affected him but someone else close to him as well.

CARSON FAMILY

In the interim before Elijah's arrest, he apparently wielded his charm on a young, impressionable girl and her family, completely hiding his questionable past from them. In spite of being a wanted man, Elijah Canary looked ahead to the future, courting and marrying Kate E. Carson in Ogden, Utah, on November 17, 1895. The newspaper printed a notice. "Late Saturday a marriage license was issued to Eliza [Elijah] Canary, aged 28, and Kate E. Carson, aged 16, both of Ogden. Rev. T.L. Crandall of the Baptist church last night performed the ceremony uniting them in marriage." Her sister, Mollie, then fourteen, and Edward Pearce were their witnesses. "The wedding was very quiet owing to the illness of the bride's mother," the newspaper explained.[188] Perhaps the bride's mother's illness was brought on by her young daughter's marriage.

However, Kate wasn't from an ordinary family. Katherine Exarmina Carson was the eldest daughter of Frank and Irene Carson's rather large, prominent Ogden family. Her father, Frank, hailed from Louisville, Kentucky. He traveled extensively as a child, and on his return from Australia to New Orleans, he learned of the Civil War. He immediately joined the Confederacy. While serving, he attained the rank of captain before the war ended.[189]

After the war, he joined the migration west, stopping in Colorado, where he found employment driving stagecoaches with the Ben Holiday Line. The Mason and Gano Company employed him driving stages from Cheyenne to Denver. While in Colorado, he married Irene Jane Carroll at Fort Collins in 1869. Frank helped survey for the railroad and was present when gold was

discovered in Cripple Creek, Colorado. In 1883, he came to Ogden, Utah, where he and his wife became active in civic and community affairs.[190]

When he died in 1908, the obituary heralded his accomplishments and community regard.

> *Frank Carson, one of the oldest and best-known residents of Ogden, died this morning at 8 o'clock, at his residence, 2259 Read avenue. Death resulted from a complication of liver complaint and tuberculosis. The deceased was born in Louisville, Kentucky, May 9, 1840, and participated in the war of the Rebellion as a captain of the famous Louisiana Tigers on the Confederate side. He was one of the early "whips" on the overland stage route and on two different occasions had his stage robbed of its horses by Indians. He was a second cousin of the famous Kit Carson, had traveled extensively in all parts of the world, and leaves a host of friends from California to the Missouri river to mourn his loss and revere his memory. The funeral will be held from the residence at 3 p.m., Sunday, members of the local G.A.R. attending by reason of a request he made just before dying.[191]*

Not surprising, another obituary's headline read, "Kit Carson's Cousin Dies in Ogden." And still another obituary stated that he was intimately acquainted with such immortal characters as California Joe, Buffalo Bill Cody, Wild Bill Hickok and Major Inman.[192]

Frank's wife, Irene Carson, also possessed a list of credentials. She bore and raised nine children, including two sets of twins, and she was actively involved in the Ladies of the Maccabees, the Silver Hive, No. 1, where she served in several offices, one of which was lady commander.[193] When Irene died on June 16, 1923, the Ladies of the Maccabees demonstrated their regard by making plans to drape the charter in memory of her during a memorial service in July.[194]

In light of the family being dedicated to community and civic affairs, the presence of an outlaw in their midst would seem unlikely. However, considering the number of outlaws operating in the West, perhaps this wasn't so unusual. The details of when and where Elijah Canary met and charmed this law-abiding family is, unfortunately, a mystery.

It was not a happy first Christmas for the young couple. On December 3, 1895, less than one month after Elijah and Kate's marriage, a criminal warrant from the Uinta County was issued for his arrest. The newspapers were ecstatic about nailing the outlaws, but Kate would have been horrified.

Elijah Canary was charged with the crime of placing obstructions on a railroad, namely horses. This rather brutal crime brought about the order for his arrest. A warrant was also issued for Oliff Helquist (also spelled Hilquist), alias J.B. Johnson, and William Dawling, alias William Kunz, the same day.[195]

Confusion exists as to exactly where Elijah was arrested. The *Ogden Standard* headlined a news flash, "An Important Arrest, Elijah Cannary an Alleged Wyoming Criminal Jailed Here Saturday." The newspaper reported that Sheriff Wright arrested Elijah Canary in Ogden at Landsberg's saloon. Canary was wanted in Idaho and Wyoming to answer to several charges against him. Sheriff Ward of Evanston, Wyoming, telegraphed Sheriff Wright that he would be there the same day with requisition papers for Canary. Elijah was said to be one of the ring leaders of an organized gang of outlaws that, for several years, had been operating in Wyoming and Idaho. It can be concluded from the article that Elijah had been stealing horses for a number of years:

> *It is said that their method has been to steal horses…This nefarious scheme is said to have been worked very successfully and the gang has obtained several hundred dollars through the courts in this way. It is said that another of the ring leaders of the gang is now in jail in Evanston and others are being arrested on suspicion of being implicated in the work of the criminals.*[196]

Several newspapers carried the information that the dreaded horse thieves operating in their area had been arrested. In January, a Laramie newspaper reported, "Lige Cannary [Canary] has been arrested in Uinta County charged with herding his horses on the railroad track at night for the purpose of having the cars kill them so that he could secure damages from the railroad company." An Idaho newspaper reported that it was a discouraging chase, but the officers finally managed to secure evidence sufficient to warrant the arrest of Will Kunz and Elijah Canary on the charge of driving stock onto the track in Wyoming for the purpose of filching dollars from the Union Pacific.[197]

Sheriff J.H. Ward of Uinta County responded that he had received the written warrant on December 10, 1895, and "served the same by arresting and taking into custody the written named defendant, Elijah Cannary [Canary] and have him now in custody subject to the order of the court."[198]

It was several months later, on April 14, 1896, that Kunz, who listed his occupation as a farmer, was arrested and confined to the county jail awaiting

trial. Duncan McLennan, a businessman from Cokerville, Wyoming, who knew him and the Kunz family from Montpelier, Bear Lake County, wrote to Judge Jessie Knight attesting to William's moral character. Referring to Kunz, Duncan wrote that Kunz must have been influenced by other men. Furthermore, McLennan vouched that the Kunz family was very respectable and held a high standing in the community. He asked for leniency in passing sentence, stating that Kunz's wife and family were dependent on him for their daily food. McLennan opined that "this will be a good lesson to him."[199]

Several months after Elijah and Kate's marriage, the April 22, 1896 issue of the *Wind River Mountaineer* reported that Elijah Canary and William Kunz pled guilty to the "charge of driving horses upon the intention of having them killed by trains and thereafter demanding remuneration from the railroad company." A sentence had not yet been passed on the offenders. The newspaper added that "Canary is a brother of the famous Calamity Jane." The newspaper connected Calamity and Elijah in print.[200]

The men were convicted and sent to the Wyoming territorial penitentiary in Laramie. The *Statesman* wrote it was known there were others in the gang, but the officers were unable to lay their hands on them. Finally, a confession was secured from one of the Wyoming convicts implicating Helquist. Unfortunately, he was already an inmate of the Idaho penitentiary. The arresting officers had planned that Helquist would be turned over to Officer Jones. "A requisition for his extradition to Wyoming was issued yesterday," the May newspaper said.[201]

In the meantime, Sheriff Ward delivered the convicts to the Laramie warden. Judge Knight sentenced William Kuntz to seven years for obstructing railroads and Elijah Canary five years for obstructing railroads.[202]

The plan for Helquist's capture was put in place. Officer Joe Jones from Bear Lake County was present to arrest Oliff Helquist the moment he stepped from the Idaho penitentiary, where he had been incarcerated for one year for grand larceny committed in Bingham County. The newspaper termed the charge against Helquist as peculiar. "Helquist," the newspaper reported, "was one of a gang that for some time bled the Union Pacific in Idaho and Wyoming."

The plan of the crowd was to run a herd of stolen stock onto the railroad track and keep them there until a train came along during the night and

tore some of them into mince meat. A claim for damages would then be filed and, after the usual red-tape process, a compromise would be affected, whatever the gang received being clear profit. The frequency with which claims came in from first one and then the other of the gang aroused the suspicions of the Union Pacific officers and detectives were placed on their trail.[203]

By September 12, 1896, Helquist, who was a laborer by occupation, was confined in the county jail. Apparently he wasn't worried about his fate, as he and purported murderer Frank Murtha were noted as building "an exceptionally fine model of an American Vessel." Frank Murtha was indicted for the murder of William Crawford, but the case would be dismissed for lack of proof.[204]

The stay in the county jail didn't last long for the twenty-nine-year-old Helquist. He was sentenced on September 26, 1896, to serve a two-year term and discharged in the spring on June 17, 1898, without any pardon.[205]

It's interesting to note that Elijah's two accomplices, Helquist and Kunz, were Mormons from Montpelier, Idaho. Montpelier, located in southeastern Idaho, was founded by the Mormons and named by Brigham Young. Since Elijah lived and perhaps worked in the area, he had the opportunity to meet these two men. It appears that Elijah lived in areas where Mormons were concentrated. Since he may have lived in a Mormon home when he was young, he probably felt comfortable and secure. Elijah Canary claimed to be Mormon at one point in his life, while in another instance he admitted to little religious training.[206]

William Kunz pled for pardon in July 1897 on the grounds that his family, consisting of a wife and two children, was destitute. The Idaho sheriff and the Oregon Short Line blocked the pardon; however, Governor William Richards, who was criticized for the number of pardons he had given, commuted the seven-year sentence. Kunz walked out of prison on January 24, 1899, one year and seven months earlier than Elijah would.[207]

Elijah's exposure as a criminal must have been a shock to Kate. How his arrest and imprisonment affected their marriage would have been devastating. Kate was an impressionable young lady just recently wed and expecting their first child, who would be born on July 8, 1896, after her husband was admitted to prison. She apparently held no hard feelings against Elijah at the time, for she named her son Frank Elijah—Frank for her father and Elijah for her incarcerated husband.[208]

Most sheriffs and deputies seldom attempted to roust outlaws from their hideouts. When they did, they were sent packing. *From the* San Francisco Call, *April 3, 1898.*

Whether Kate had any clue about Elijah's wayward life beforehand is not clear. Conceivably prompted by Kunz's early release on January 24, 1899, attorneys Allen & Allen of San Francisco, upon the request of Kate and her family, sent a plea to Governor Richards of Wyoming on January 31, 1899, in an attempt to get executive clemency. Apparently, at the time, the Carson family believed Elijah was a victim of circumstances.

In a letter, attorneys from San Francisco brought to the governor's attention that Canary had been employed by Kuntz (Kunz) and was only following orders. Furthermore, the attorneys pointed out, "That but a short time prior to his imprisonment the said Canary was married and his wife and child are now suffering for the necessaries of life and are dependent upon the said Canary for support."[209]

A sketch of Butch Cassidy appearing in the newspaper with the headline "Rounding up Outlaws in the Colorado Basin." *From the* San Francisco Call, *April 3, 1898.*

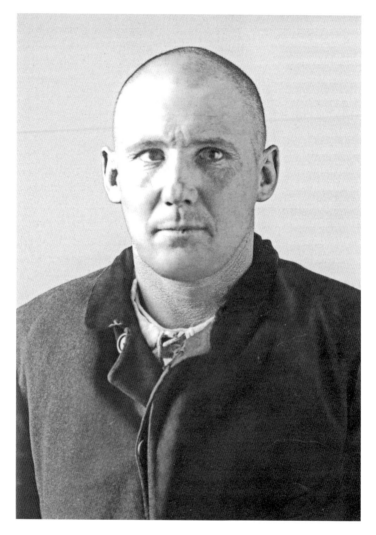

A mug shot of Elijah Canary at the Laramie territorial prison, circa 1896. *Wyoming State Archives, Department of State Parks and Cultural Resources, Penitentiary Collection #00253.*

Within the three-page letter, Allen & Allen stated:

Mr. Canary's wife and her family desire the pardon of her husband. First:— Upon the ground that he was not interested or connected with the crime except as a hired servant...Second:—He has served almost three (3) years of his sentence and was the willing witness for the State to bring the

guilty leader to justice. Third:——He was never charged of crime before and has not since conducted himself as a willful criminal. Fourth:——His wife and family guarantee to bring him to California where he can support and care for them. Fifth:——The ends of justice have been fully compensated by his imprisonment. Sixth:——Executive clemency is the only hope of relief in such cases.[210]

Six months after the plea for early release, Elijah Canary was discharged on August 12, 1900, for good conduct, shortening his original sentence of five years by 255 days. Did he and Kate go to California as planned? What happened between Kate and Elijah between February 1899 and August 1900 is unknown. However, according to the 1900 census, Kate and son Frank, age three, were living with her parents and family in Ogden. The census recorded Kate as being divorced. She and her sister Mollie were working as sales ladies to help support the twelve-member household.[211]

In light of the census information, Elijah walked out of prison a divorced man. His wife had given up on him. He was on his own once again, but where would he go next?

8
OUTLAW TRAIL

The years between 1900 and 1905 are devoid of information either for Kate or for her ex-husband Elijah. The family cousins believed that Calamity's brother Elijah rode with Butch Cassidy, the Sundance Kid and the Wild Bunch. Although there is no evidence to confirm this, it is possible that he could have, for a time.[212]

Elijah could have ridden a portion of the outlaw trail that extended from Mexico to Canada, encompassing a region of both desolation and lonely beauty. Mountains tinted in polished purples, rosy pinks, reds, dusty beiges, burnished yellows and cool grays towered over expansive basins of sagebrush. Scrub cedars clung to rocky cliffs while canyons and gorges twisted and turned into impenetrable hideouts used by the numerous outlaws who menaced the area residents in the late 1800s and early 1900s. Through these sagebrush valleys, outlaws drove stolen horses and cattle into these natural holding pens.

This western topography attracted a host of bad men. Nature had carved fortresses and strongholds not easily accessible—a haven of hideouts for those escaping from the law. Elijah was not as infamous as Butch Cassidy, the Sundance Kid, Teton Jackson and other notorious characters, but his name did appear several times in newspapers and on lists of prison inmates. His name has not been connected with the Wild Bunch. In regard to notoriety, he would be classified as one of the many lesser outlaws of the time. There were so many much worse than he. Many of these outlaws progressed from stealing horses to cattle rustling, and others were drawn on to robbing trains and banks.

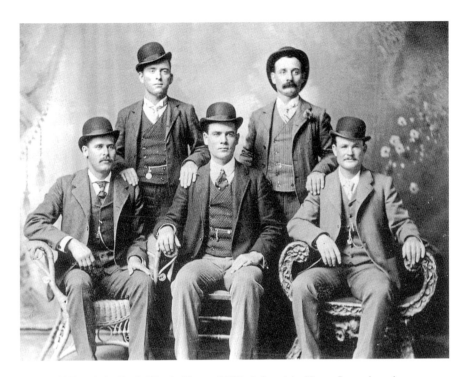

The Wild Bunch in Forth Worth, Texas, 1900. *Left to right*: Harry Longabaugh (Sundance Kid), William Carver, Ben Kilpatrick, Harvey Logan and Butch Cassidy. *Author's collection.*

However, according to the limited information concerning Elijah, it appears he concentrated his attentions in western Wyoming and eastern Idaho, with recurrent trips to Ogden and perhaps the Blacks Hills of South Dakota. He frequented Mormon enclaves, perhaps feeling safe within their community.

Elijah had many opportunities to go astray, as many outlaws began their wayward life as horse thieves in these wide-open spaces where horses were plentiful and the area remote. Most lawmen did not approach these secluded hideouts where ambush would have been certain. However, there were a few lawmen who followed in pursuit. One such sheriff was John Howard Ward, who had crossed paths with Elijah.

The Wyoming newspapers often praised Sheriff Ward's career. Considered "one of the best sheriffs in the West," the newspapers credited him, along with Attorney Sammon, with cleaning the country of criminals of all classes. John Ward came to Wyoming in the 1880s and was elected to the position of sheriff, an office he held for fourteen years. He had served in the Sixth Iowa Cavalry of the Union army, where he

gained valuable experience. Later, he became a freighter on the plains before he served the public as sheriff.[213]

In 1890, Sheriff Ward brought back Bill Davis from Butte, Montana, on charges of horse stealing, but in 1891, the newspapers announced that the Uinta County jail was empty:

> *Not a solitary prisoner is confined within its walls, and the jailor for want of something else to do, puts in his time playing checkers with the county attorney. This condition of affairs has not existed before for five years or more, or not, since Sheriff Ward has been in office, and it speaks well for the efficiency of the court in promptly disposing of the prisoners arrested and brought before it.[214]*

Praise was a little premature, as the situation changed in 1892. Unidentified horse thieves had been operating in northern Uinta County, where they drove off ten head of horses belonging to David Dickie, most of Patrick Barrett's horses and about forty head of Jack Piper's horses. They were driven into Idaho, where, it was speculated, Sheriff Ward would pursue their trail and capture them. This scenario uncannily fits Elijah's modus operandi.[215]

The year 1892 was a busy one for Sheriff Ward. He helped arrest horse thieves across the state line into Utah. The thieves had been invading settlements near Lander. Sixty-two head of horses had been recovered and the thieves were taken to Lander. No mention was made of who the thieves were.[216]

At times, horse stealing became violent. In April 1892, the newspaper reported that Sheriff Ward had arrested six horse thieves with his deputies within the last six months. One of those arrested, according to the newspaper, was Butch Cassidy. Two others, Gott Spencer and Jack Burnett, were killed near Jackson Hole.[217]

Butch Cassidy, born George LeRoy Parker, grew up in a Mormon home near Circleville, Utah. He began his lawless life by stealing horses and would become one of the most famous outlaws of the time. Butch Cassidy and partner Al Hainer came to the Lander area, Elijah's old stomping grounds, in the fall of 1892. The two men established a ranch, perhaps used as a front for their horse-theft operations. The winter of 1892–93 slammed the region with extreme cold and snow. The range stock either froze or starved to death. By the spring of 1893, they had sold their ranch and spent their time in the Lander saloons and gambling joints. Elijah was reported to have been living in Freedom at this time.[218]

Uinta County, Wyoming, a county where Elijah operated, seemed to have been infiltrated with numerous horse thieves. Sheriff Ward recognized that there were lots of stolen horses going east, but he said he was going to break up the business in Uinta Country or bust. Cassidy and Al Hainer were arrested for horse theft in June 1893 but, for some unexplained reason, were acquitted.[219]

Apparently, the arrest didn't curb Cassidy's appetite for horse theft. In 1894, a Montana sheriff and Ward's deputy, Bob Calverly, arrested Cassidy, along with his partner, Al Hainer, near Star Valley, the same area where Elijah Canary was said to have resided. Surely, Elijah and Cassidy encountered each other somewhere.[220]

Cassidy and Hainer were taken back to Lander to stand trial. An affable fellow, Cassidy had made friends while in Lander a few years earlier. Some of his friends wrote up bills of sale for the stolen horses, but when news of this scheme leaked out, Butch was convicted for his crime and sent to Laramie prison on July 15, 1894. Al Hainer was acquitted.[221]

Cassidy walked out of prison a free man in January 1896; however, Elijah Canary would hear the cell door slam behind him in the very same prison five months later.

After Cassidy was released from the penitentiary, he changed his focus from horse and cattle theft to bank and train robberies. An article in the 1898 *San Francisco Call* entitled "Rounding Up Outlaws in the Colorado Basin Territory Over Which the Outlaws Roam: Active Campaign by the Governors of Four States Against Butch Cassidy and His 500 Freebooters" sounded an alarm. However, by the time this news was printed, Elijah Canary was already incarcerated in the Laramie prison.

"Butch Cassidy is a bad man," the newspaper said. At the time, he was harassing the states of Utah, Colorado, Idaho and Wyoming. The four governors met in a secret assembly to devise a plan of action "against the most notorious outlaw the West has ever had to cope with. The achievements of Jesse James and his followers pale into tawdry insignificance before those of 'Butch' Cassidy and his five hundred." Sheriff Ward—who was a dedicated sheriff, unlike some other sheriffs who were former criminals themselves—had estimated that the total strength of the outlaws was up to five hundred members, but the supposed number may have been an exaggeration.[222] Was Elijah one of his so-called five hundred? There is no evidence to prove that he was.

According to the newspapers of the time, the situation was desperate. The "ordinary methods of hunting outlaws" had proven unsuccessful; even the rewards offered for Cassidy had not brought him to justice.

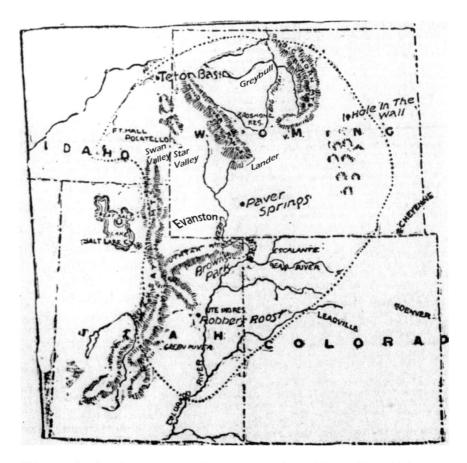

This map of outlaw hideouts appeared in a newspaper along with an article entitled "Rounding up Outlaws…" *From the* San Francisco Call, *April 3, 1898.*

Their depredations are upon a scale never before reached in the history of frontier crime. All the conditions are favorable to them. They know every foot of the vast territory in which they operate, taking in, as it does, the wildest and most inaccessible portions of four States.[223]

The Wild Bunch, most active after Cassidy's prison release, was thought to have been an "exclusive group, never numbering more than twenty-five to thirty members. Only five or six men worked a job and they traveled together in pairs, usually no more than three."[224]

Since Elijah Canary was imprisoned at the territorial prison in Laramie at the time the San Francisco article was written, he was probably not a part of the Wild Bunch. He was incarcerated for four and a half years during the

years the Wild Bunch was lively, but he certainly could have had previous contact with some of these outlaws.

From 1900 to 1904, the Wild Bunch was still robbing banks and trains. Elijah could have possibly ridden with them during this period after he was released from prison in 1900, but would he risk imprisonment so soon after being released? Besides, there is no proof Elijah was a bank robber; he was a horse thief. Then, by 1904, Butch Cassidy was reported to be in South America.

This sketch of Butch Cassidy and his outlaws appeared in a California newspaper. *From the* San Francisco Call, *April 3, 1898.*

However, the Ogden, Utah post office posted a letter list in the May 27, 1902 issue of the *Ogden Standard*. Elijah Canary's name was listed, suggesting Ogden may have been his home base during this period. This may signify he was once again involved in horse stealing, or did he attempt reconciliation with Kate and visit his son?[225]

Family history also suggests that Elijah worked on the Dave Dean Ranch after he was released from prison. The Dave Dean Ranch was located on Yellow Creek near Evanston, Wyoming. David Dean, a prominent rancher in the area, possessed a penchant for horses. Not only was David Dean a rancher, but he also was active in community affairs. He organized round-ups and Wild West shows, horse racing and bucking contests in Evanston. Sometime after 1906, he expanded and purchased the Uinta Stock Farm, stables and racetrack from the A.C. Beckwith estate.[226]

The newspaper credited A.C. Beckwith's stables as "containing today some of the best horse stock in America." Beckwith sold breeding stock and was one of the wealthiest men in the state. Beckwith shipped two carloads of his race horses, eleven stallions and two fillies, to Salt Lake City in 1892 for the June races from the "best stables in the West," according to the Salt Lake City Driving Association.[227]

If Elijah worked at the David Dean Ranch, he may have had some connection with the stables and racetrack, even if Dean did not own them (he only leased them at the time). The *Wyoming Press* of 1897 reported the "Evanston Agricultural Stock and Driving Association was formed by a few of our citizens, and as a preliminary move toward the real object of the association. They secured a lease on the track and grounds of the Uinta Stock Farm, where they expect to have racing meets during the summer."[228] For someone who rode horses as well as Elijah, it is probable he would have visited the racetrack at some time.

Still, there is no concrete evidence, only speculation, of where Elijah went after leaving the Laramie prison.

CALAMITY'S LAST YEARS

In 1894, Calamity was back in Green River, apparently broke; however, she rented a house and intended to stay, according to the newspaper. As usual, her stay was brief. The house suddenly became empty when she left for Pocatello. "The Green River folks breathed more freely," the newspaper informed them.[229] What was Calamity doing in Pocatello? Could she have gone to visit her unnamed sister or Elijah, who may have frequented the area?

This is what Calamity dictates in her autobiography:

> *When we left Texas we went to Boulder, Colo., where we kept a hotel until 1893, after which we traveled through Wyoming, Montana, Idaho, Washington, Oregon, and then back to Montana then to Dakota, arriving in Deadwood October 9th, 1895, after an absence of seventeen years. My arrival in Deadwood after an absence of so many years created quite an excitement among my many friends of the past, to such an extent that a vast number of the citizens who had come to Deadwood during my absence who had heard so much of Calamity Jane and her many adventures in former years were anxious to see me.*[230]

In 1893, Calamity may have been in Wyoming and other states she said she visited, but she did visit Deadwood as she described. Indeed, Deadwood was excited to see her. A lengthy article appearing in the newspapers verified her visit. The headlines read: "Famous Black Hills Characters Visits the Scenes of Former Escapades." The *Deadwood Times* recorded the event in

these words: "'Calamity Jane in town!' This and similar remarks could be heard everywhere on our streets yesterday afternoon."[231]

Calamity would have found Deadwood to be very different than when she left it in the late 1870s. It wasn't the wild and wide-open gold rush town any longer. Reputable businesses were replacing the saloons; churches and schools brought respectability to the area. The railroad had arrived.

The newspaper explained that Hank Jewett drove to the Elkhorn depot to pick her up. She appeared in town rather shabbily dressed with a little girl beside her. The newspaper interviewed her in front of the courthouse shortly after her arrival. The report began with all her positive attributes:

> She [Calamity] *has always been known for her friendliness, generosity and happy, cordial manner. It didn't matter to her whether a person was rich or poor, white or black, or what their circumstances were, Calamity Jane was just the same to all. Her purse was always open to help a hungry fellow, and she was one of the first to proffer her help in cases of sickness, accidents or any distress.*[232]

The article confirmed that she had been living with her husband on a ranch about fourteen miles from Ekalaka, Montana, north of Deadwood. She had been living there the past summer, but "Jane did not like that kind of a life and came to Deadwood with the intention of residing here." The newspaper assured the readers that Jane was looking for respectable employment that would support herself and the little girl, as well as give the child "the benefit of the schools." Jane told the reporters that her husband (Clinton Burke) brought her down to Belle Fourche, where she took the train for Deadwood.[233]

In November, she traveled to Rapid City in the train's smoker car to sell studio pictures of herself in male garb taken at Locke & Peterson Photography while she was in Deadwood. The newspaper reported that the old-timers were especially happy to purchase the photo of her dressed in buckskins. To them, it brought back fond memories of earlier days. While in Deadwood, she used her pictures as currency, often plunking photos down on the bar in exchange for drinks.[234]

However, in spite of her respectable intentions, she frequented the bars and made a nuisance of herself in several Black Hills towns. She went on a drunken spree in Hot Springs that offended the reporter. "She seemed to have an idea she owned the town," the Hot Springs newspaper reported, unappreciative of her presence.[235]

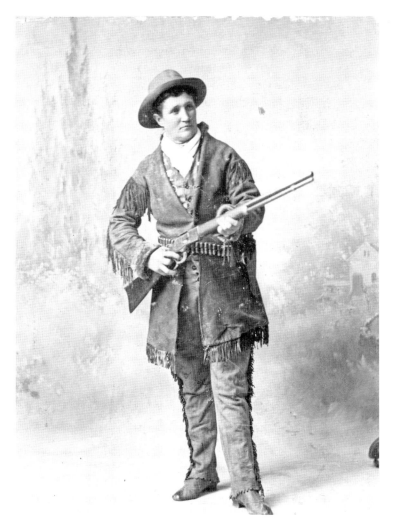

In 1895, H.R. Locke photographed Calamity Jane in Deadwood. She sold these photographs along with her autobiography on her trips across country. *Library of Congress Prints and Photographs Division, LC-DIG-ds-05297.*

Clinton Burke was with the nearly forty-year-old Calamity in Deadwood when she was interviewed by female reporter M.L. Fox, who managed to tap into Calamity's soul and melt Calamity's rough exterior. Calamity wept several times during the interview, recalling the mistakes she had made. She expressed a genuine desire to educate her daughter, Jessie, so she could have a better life. Calamity admitted to the reporter, her eyes overflowing with tears, that she had been tough and lived a bad life. She wanted to be

respectable, but she knew it was too late. Calamity's daughter, Jessie, came home from school before the interview concluded. The reporter noticed she was nicely dressed. Sadly, Jessie, too, had endured the taunts from her schoolmates because she was Calamity Jane's daughter.[236]

Calamity's autobiography continued:

> Among the many whom I met were several gentlemen from eastern cities who advised me to allow myself to be placed before the public in such a manner as to give the people of the eastern cities an opportunity of seeing the Woman Scout who was made so famous through her daring career in the West and Black Hill countries.[237]

Calamity finished her short autobiography with these words:

> An agent of Kohl & Middleton, the celebrated Museum men came to Deadwood, through the solicitation of the gentleman who I had met there and arrangements were made to place me before the public in this manner. My first engagement began at the Palace Museum, Minneapolis, January 20th, 1896, under Kohl and Middleton's management. Hoping that this little history of my life may interest all readers, I remain as in the older days,
>
> <div align="right">
>
> Yours,
>
> Mrs. M. Burk
>
> Better known as Calamity Jane[238]
>
> </div>

Calamity was about to capitalize on all her exaggerated escapades with her appearance at the Chicago Dime Museum.

The *Daily Inter Ocean* newspaper reported on her appearance:

> The most interesting woman in Chicago at the present time arrived here Sunday night from the West. She wears buckskin trousers and is not afraid of a mouse...Calamity was married upwards of ten years ago, to a ranchman named Burge. Her husband has long been dead, and now, in order to educate her little 9-year-old daughter, who is attending school in Deadwood, Calamity Jane is appearing in public.[239]

The reporter, as all reporters before him, missed the mark on several statements. The ranchman was Burke not Burge. Calamity hadn't been married to him for ten years, and he was not dead, as the newspaper erroneously stated. Burke would reappear with Calamity in Montana.

A sketch of a young Calamity Jane appearing in the newspapers. *Crook County Monitor*, November, 23, 1898. *Author's collection.*

A Douglas, Wyoming newspaper claiming the ubiquitous Calamity announced, "Our Calamity Jane is on exhibition in a Chicago Dime Museum."[240]

The March issue of the *Minneapolis Tribune* flashed a daunting sketch of Calamity appearing in her buckskins, holding a rifle in one hand and a bowie knife between her teeth. The accompanying ad reported that Calamity, the

most daring and famous woman scout, would make her farewell appearance before retiring to private life in her Black Hills home.[241]

She didn't retire to private life in the Black Hills as the newspaper stated; instead, she visited Cheyenne and Sheridan in June 1896, selling the history of her life in an attempt to eke out a living. But she didn't dally long there either, for gold discoveries in the Yukon raised hopes of elusive wealth and wild excitement. Calamity left to join the throng of prospectors during the first part of June.[242]

The trip to the Yukon's Klondike in northwestern Canada apparently took several weeks. Calamity arrived in Dawson, Yukon Territory, around June 23, 1896. The *Klondike Nugget* picked up on her appearance and alluded to her life of wild adventures but comically tempered her need to take human life by reminding the reader of her "gentleness and refinement…as any of her eastern sisters." It was noted her "half-sad face indicates that her life has not been all sunshine."[243]

No mention was made of anyone with Calamity; however, Captain Jack Crawford, her Black Hills acquaintance, acknowledged as a famous scout and poet, was expected to reach Dawson in a short time. The *Nugget* predicted the citizens would "have an opportunity to listen to the poet-scout's literary productions."[244]

The Klondike gold boom lasted from 1896 to 1899, when gold was discovered around Nome and sent the miners scurrying to Alaska. Calamity didn't stay long in the Klondike. She came back to Montana without a fortune.[245]

The newspapers resurrected a young and vibrant Calamity Jane to accompany their stories of her. An illustration of an agile, western-clad Calamity appeared in the *Crook County Monitor* in 1898 along with a lengthy article about her own proclaimed escapades. At the time of the article, Calamity was residing near the Crow Agency, in proximity to the Custer battlefield, and she looked nothing like the sketch circulating the country. A Casper newspaper also wrote of Calamity residing on a ranch near the Crow Agency in Montana, within sight of the battlefield. The newspaper then reported, "Mrs. Burk's voice glows in praise of Gen. Custer, whom she describes as absolutely fearless…From her front door may be seen the tomb of Gen. Custer, and to this fact may be ascribed the principal reason for her residence there." Genealogy records state Cilus also died there on June 25, 1876, at the age of nineteen. But he is not on the list or the monument of those killed at the battle site. He actually died in Missouri at the age of five.[246]

As usual, Calamity didn't stay on the ranch long. She had transferred to Billings. In 1899, Calamity was doing her best with her deteriorating health

to make ends meet. Calamity had the misfortune of being robbed while she was in Billings. She had been working at the laundry at the Cottage Inn. A gold watch and some money were stolen from her room in her absence. In March, Calamity Jane landed another job of "holding down a position as kitchen mechanic in Billings."[247] On one of her trips to Billings, she may have encountered her nephew Tobias Borner, who was freighting from Billings to Lander.

A month later, Calamity made her appearance in Butte, Montana, during April. It was said she came down from Fort Bridger looking for her husband, who had "skipped for parts unknown with a younger and handsomer girl."[248] The husband she was referring to may have been Robert Dorsett, whom she had hooked up with for a while.

During her wanderings, she met up with her acquaintance George Reeb, who claimed to have met Elisha (Elijah) Canary in Evanston, Wyoming, in 1900. During the course of their conversation, Elijah asked if Reeb knew Calamity Jane. He said he did, and Elijah said that Calamity was his sister and he was her "baby brother." Sometime later, Reeb told of the encounter to Calamity. According to Reeb, when she heard of their meeting, she "sobbed like a child."[249] Judging from this reaction, Calamity had lost track of her brother.

Likely, George Reeb met Elijah in prison in Laramie and not at Evanston. George Reeb was serving a sentence, too, for charges of holding up and robbing a number of coaches and two government ambulances in Yellowstone National Park on October 14, 1897, with the assistance of partner Gus Smitzer.[250]

Still short on funds, Calamity Jane was in Miles City in January 1901, searching for employment as a cook. "If she fails there she will go on next to Forsyth and next to Billings," a newspaper reported. Calamity didn't find a good-paying job or she simply didn't stick with the job, for newspaper headlines leapt off the pages reporting that Calamity had been reduced to living at a poor farm. "Calamity Jane has been admitted to the Gallatin County poorhouse," the newspaper said.[251]

Apparently, the news of her being penniless brought in monetary donations from her admirers and people living in the East. She was said to have been well off for a while anyway. But not only did the newspapers' proclamation aid her financially, but they also alerted an eastern woman with questionable motives. As a result of this announcement, which circulated in the newspapers across the country, a Mrs. Josephine Winfield Brake of Buffalo, New York, journeyed to Montana searching for the famous

Calamity Jane. Mrs. Brake, who was a noted journalist and author, found Calamity in an African American woman's hut near Livingston, Montana. When asked why she was so interested in Calamity, Mrs. Brake responded, "I have read much about her…I am going to provide a home for her…I am sure that a character that has shown evidence of so much daring courage and strength has other good qualities, and I am going to do the best I can for her." After much debating, Calamity took her up on her offer and went home with her to Buffalo, New York.[252]

The nature of a Helena, Montana newspaper's report, "Calamity Jane Leaves Montana," potentially reduced the tender-hearted reader to tears. Reminiscing that Calamity came to Montana thirty years earlier, the article wrote that she would "never be forgotten as one of the odd characters of the early days of the state…She figured prominently with and was a product of the rugged frontier as a scout, cowboy, Indian fighter, and poker player."[253]

Those not appreciative of Calamity's frontier charms cheered with the news that she was finally leaving the West. Little did her critics know that Calamity would be returning to the only life she had known. She wasn't about to give up her whiskey or her smoking and definitely not her freedom.

After several months in Buffalo, New York, trouble was brewing between Calamity and her angel of mercy. A newspaper noted in its October 1901 issue that the cheap novelist who took Calamity Jane to take care of her in Buffalo utilized her as a sideshow freak to make money, "and Jane has balked." Brake had arranged for Calamity to appear in the Pan-American Exposition, an extension of Colonel Fred Cummins Indian Congress, to be held in Buffalo, New York.[254]

Indeed, Calamity had had enough of Brake's restrictions. Calamity lived with Mrs. Brake until the fall of 1902, when she grew tired of the East and being watched by her caretaker. She persuaded her friend Buffalo Bill Cody to buy her a ticket and give her expense money for her return to Montana.

Calamity was reported to have made things lively at several points along the way to Montana when she detoured to her old haunts and the regions she knew best. She stopped off in Chicago and then booked an engagement in Minneapolis at the Palace Museum in October. From there, she wandered into Pierre, where the newspaper wrote verbosely, "She renewed the gayety of her youth by stowing away under her belt a quantity of hopified elixir and then proceeded in a semi-facetious, semi-serious manner to make things interesting."[255]

She also stopped in Oakes, North Dakota, en route to Livingston, Montana. She spent a night in Oakes and startled the men in one of the

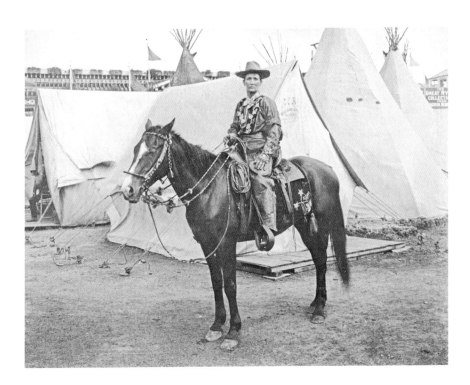

Above: Calamity Jane sits astride her horse at the Pan-American Exposition in Buffalo, New York. Photographer C.D. Arnold. *Library of Congress, Prints and Photographs Division, LC-DIG-ds-05299.*

Right: A sketch of Calamity Jane appearing in the newspapers. *Rock Island Argus*, Rock Island, Illinois, February 24, 1896. *Author's collection.*

saloons. She was drinking and called the men up to the bar. Calamity was no longer young and looked a little worse for wear, certainly not the woman legends had created. The men proceeded to have "fun with Calamity." Calamity tolerated them for a while and decided to have a little fun of her own. She pulled out a couple of guns and told them to dance. "You fellows have had your fun and now it's my turn," she said. "You don't know as much as the calves out on my Montana ranch." The boys danced. One man in the crowd wasn't about to take orders from Calamity and didn't oblige while laughing at her antics. She noticed he wasn't drinking and ordered him to do so. She pulled out her side-iron and backed up her command with the aid of the wicked-looking gun. The man quickly gulped down his glass of beer.[256]

Calamity had used the same tactic when she was in Fort Pierre. Some men loitering in a general store were making fun of her. In response, she took out her pistols and shot at their feet.[257]

Calamity reached Billings from the east, coming from Pierre, South Dakota, a newspaper announced. "She looks as though the world has treated her roughly since leaving this section for the East."[258]

Finally, in April 1902, Calamity arrived in Livingston. "Calamity is home again from her wanderings far and wide…Here among her friends once more, honored and revered yet, she comes to stay and spend her days," the newspaper wrote of the old gal, but then realistically added in the last line, "And I'm [Calamity] off for my stys again."[259] Sadly, the town citizens may have chuckled, but unfortunately, Calamity was at the mercy of alcohol.

Apparently, the region harbored mixed feeling about Calamity's return. In June, Livingston was ready to send her on her way. Calamity had been jailed after she went on one of her sprees and was found slumbering from her jag "that would have taxed the capacity of an elephant," the newspaper wrote. Afterward, she was occupied playing checkers on a window grate at the county jail. "The following day she was released on promise that she would leave town."[260]

Referred to as "this Old-timer," a Montana newspaper acknowledged Calamity had a deal of grief since her Pan-American trip and "has not recovered from the effect of her eastern tour." She was also reported to be in bad health and had little money.[261]

It was true. Calamity began experiencing ill health and drinking heavily while living in Montana in 1902. The newspaper reported that she was "disgusted with a community that so little appreciates her fame as to sentence her to sixty days in the county jail." She became ill while serving her time

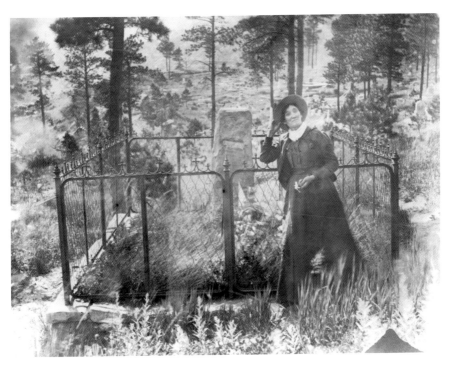

Calamity Jane visited Wild Bill Hickok's grave at Deadwood's Mount Moriah Cemetery in 1903. Photographer J.A. Kumpf. *Library of Congress, Prints and Photographs Division, LC-DIG-ds-05300.*

and was transferred to the hospital. Instead of returning to jail after she recovered, "she is now on her way to Deadwood."[262]

Thinking her old friends in the Black Hills would appreciate her presence more so than the Montana citizens, she boarded the train to South Dakota. After visiting Sundance, Wyoming, and various places in the Black Hills, she settled into a hotel in Terry. She was very ill.

A Terry family recalled seeing her several days before she died. Della Anderson Busby remembered meeting and shaking hands with her on the veranda of the hotel in which she lived her final days.

Della's father, Jim Anderson, came home from work one day asking his family to guess who had come to town. But before they could guess, he announced that Calamity Jane was in town. Of course, they had all heard of Calamity. Jim Anderson told his family she had come into the saloon asking for a cowboy by the name of Roy Schaffer. She had helped him when he had been sick, and he had resolved he would help her if she needed him. While waiting for his arrival, she ordered beer for the house. Jim Anderson enjoyed

a beer on her. Whether she could afford it or not, she somehow always managed to get what she wanted, he said. In the meantime, Roy Schaffer came to her assistance like he had promised. He took her to a boardinghouse and called the doctor.

Urged by curiosity, Della and a friend sauntered by the boardinghouse the next day where they saw Calamity and Roy on the veranda. Roy Schaffer, who was leaning against the porch rail, called the girls over to shake hands with Calamity Jane, who was sitting in a rocking chair. Della recalled that she was dressed in a brown gathered skirt and an army shirt and was wearing heavy work brogans. A man's western hat lay beside her chair. According to Della, she was thin, dirty and rough looking and appeared ill. Della especially remembered the handshake. Calamity's hands were rough, hard and calloused, so unlike her own soft hands. Calamity visited with them about her daughter, Jessie, who wasn't with her.[263]

Calamity died from inflammation of the bowels on August 1, 1903, at the age of forty-seven, even though she appeared much older. A Livingston newspaper titled the news a "Famous Character, Well Known in Livingston, Dies With Her Shoes off."[264]

The Black Hills Pioneers organized her funeral, carried her coffin up the steep hill to Mount Moriah, overlooking Deadwood, the city of her earlier days, and buried her beside Wild Bill Hickok, the legend she so admired. Her funeral was the largest held up to that time. A bevy of onlookers came from miles around to attend the funeral, some from curiosity and others who had come to pay their respects. Dr. Charles B. Clark preached the sermon, focusing on her deeds of kindness. Her daughter, Jessie, who had been to Belle Fourche earlier with her, was not in attendance.

The newspapers across the nation carried her story, exaggerating her life as they always had. They used a cut-and-paste method in composing her obituaries, cutting the same untruthful stories that had circulated her entire life and pasting them with updated information, which was just as erroneous as the overused tales from yesteryear.

Frontiersman, former scout of the United States army and acquaintance of Calamity Jack Crawford responded to these tales in a letter one year later. "If the writers of such stuff are held accountable for the lives they ruin by it, the pathway to hades must be overcrowded."[265]

Crawford continued to quell the myths concerning Calamity Jane after she died by telling his story of the famous Calamity Jane in a letter to the *Minneapolis Journal*. He had known her and arrested her in 1876 for intoxication and disorderly conduct in Custer City. "Yet this is the woman

who figures as a heroine in a dozen dime novels and yellow newspapers," he wrote incredulously.[266]

Crawford was employed as chief of the scouts and explained she was never a scout, not even for General Crook, who ordered her out of camp. She was never a mail carrier, a stage driver or an express messenger, he insisted. She did not arrest Jack McCall or assist in his capture. McCall was not lynched in Deadwood, as she tells it in her autobiography.[267]

Calamity claimed it was during a military campaign under the direction of Generals Custer, Miles, Terry and Crook that she received her moniker Calamity Jane. Captain Egan supposedly christened her Calamity Jane, the heroine of the plains, in gratitude for saving his life.[268] Crawford insisted Calamity Jane did not receive her moniker from Captain Egan. He was not wounded, and Calamity Jane did not save his life. Where she received her suggestive name "Calamity" is still a mystery.

Many have attempted to solve the mystery of Martha's moniker, including Harry Wadsworth, a former employee of a Lander, Wyoming newspaper. Once, while she was in Lander, Wadsworth gave the "frontier lady" plenty of room on a boardwalk in Lander, finding himself in the mud. He contended her real name was Clementine Canary, shortened to "Calam" and expanded to Calamity, "which seemed to fit the wayward and care-free personality

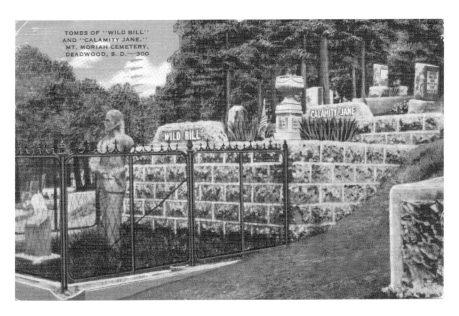

Calamity Jane's grave is located next to Wild Bill Hickok's at Mount Moriah Cemetery in Deadwood, South Dakota. *Author's collection.*

which was the result of indulging in too much frontier fire water which she seldom stopped drinking to the time of her death."[269]

A more plausible explanation may be that Billy Nye and his newspaper, the *Laramie Boomerang*, gave the name Calamity Jane to Martha Canary sometime in the early 1870s. By the time she reached the Black Hills in 1875, she already was known as Calamity Jane.[270]

Even though Calamity told fanciful tales, further enhanced by the newspapers and dime novels, Captain Jack referred to her as a "good-hearted woman" and said that she may have become a good wife and mother if she had been brought up under different circumstances.[271]

After peeling away the layers of legend, a tragic historical figure emerges. Sadly, she did die the "mistress of her own destiny," as Maguire wrote in 1877. However, hers was a destiny filled with heartache fueled by the alcoholism that she couldn't conquer.

10

BOISE

E lijah probably learned of his sister's death through the newspapers. He may have shaken his head at her antics, but he was up to his own shenanigans.

In August 1905, Elijah was once again on the hot seat. Peter G. Johnston of Blackfoot, Bingham County, Idaho, filed a complaint in the probate court of Fremont County on August 10, 1905, stating that Elijah Canary from Salt River Valley, also known as Star Valley, stole three horses belonging to Peter G. Johnston and Hyrum Severson on or about July 10, 1905, at Bitch Creek in Fremont County.[272]

An arrest warrant for Elijah Canary was issued shortly thereafter. Several days later, the Afton newspaper reported that two gentlemen by the names of Severs and Hansen were in the valley searching for their stolen horses, recovering three, two fine blacks and a cream-colored riding horse. They were in the company of A.L. Hale, deputy sheriff, who was holding a warrant for Canary, who supposedly stole the horses. They proceeded to Mr. Garrick's ranch, where Canary was stopping. Previously, arrangements had been made for an Idaho officer to meet them there. Constable Erickson made the arrest on the Idaho side. Then the Montpelier sheriff came to take the prisoner to St. Anthony for trial.[273]

The newspaper pinpointed the theft as happening in Idaho near Victor, opining, "If all parties engaged in this sort of business were hunted down and summarily dealt with, the county would soon be rid of them. Much credit is due our deputy sheriff A.L. Hale for his prompt action in this matter."[274]

The tone of a Wyoming newspaper report indicated that Elijah apparently had been involved in other forays. The paper stated:

> *Lige Canary one of the most notorious horse thieves in western Wyoming, has been captured at the Garrick ranch, north of here, and taken back to St. Anthony, Idaho, to answer for his latest crime, which was one of the boldest and most daring which has occurred for some time in the West. Canary, who is a Wyoming man, and has served a term in the state prison for horse stealing, has been operating in western Wyoming and eastern Idaho. Recently he stole a big bunch of valuable horses in Idaho, drove them over into the county and sold them to ranchmen and farmers. He was trailed to the Garrick ranch by Deputy Sheriff A.L. Hale and Constable Erickson and taken by surprise, surrendering without a struggle.*[275]

The *Guernsey Gazette* further reported from an Afton dispatch stating Lige Canary was arrested at the Garrick ranch on the Snake River. He was charged with the theft of several head of horses from A.E. Severs and H. Hansen of Victor, Idaho. The horses had been taken during the night while grazing within a mile of their owners' ranches and were driven thirty miles to a place where they were tied in a clump of trees, ridden one by one out of hiding and sold to neighboring ranchmen.[276]

An older-looking Elijah, sporting a brown mustache, was brought to court on August 14 to face his charges. His hair was still thick and brown, but his teeth were noted as being poor. His dark-brown eyes peered out from a dark, sullen face. He stood small of stature at five feet, five and one-quarter inches tall and weighed 164 pounds.[277]

The St. Anthony courthouse records not only reveal the preliminary examinations but also where Elijah may have been living for over a decade. Hyrum Severson, one of the plaintiffs, was a rancher and stock raiser and resided in Rigby, Idaho. Severson accused Elijah Canary of stealing three gelding horses: one black with a brand of *L* on the left shoulder, one black with a stripe on its face and branded *B* on the left shoulder and one buckskin horse branded *OB* with a quarter circle under it on the left thigh and an *X* with a bar under it on the left shoulder. Three horses were not the "big bunch" reported in the newspaper. The last time Hyrum Severson had seen the three horses was on about June 20 between Bitch and Conant Creeks. The next time he saw the horses was in Star Valley, Wyoming, in the possession of three men: Arch Nebeker, Edwin Baliney and James Moffatt.[278]

When Hyrum Severson was asked during preliminary examination if he had any conversation with the defendant or any conversation with anyone else in his presence at or about the time that he found the horses in Wyoming, he replied yes. Elijah was in custody at the time of the conversation.

He said Elijah claimed to have a bill of sale and that he had put his bill of sale in a book at the ranch. Constable Ericksen, who was present, asked Mr. Baliney which of the horses he owned, and Mr. Bainey and Elijah both pointed to the horses. Elijah claimed he had bought them from George Walker.

No one testified whether someone had looked for the alleged bill of sale when Elijah was arrested. William Garrick's name appeared on the list of witnesses, but no testimony from him was recorded.

The next three witnesses were from the Henrie family, brothers Joseph, James and John. All were familiar with Elijah Canary.

Joseph Henrie, who was a rancher near Leigh, Idaho, testified that he was acquainted with Elijah Canary and that he had employed him to drive mail for him. He testified that Elijah quit working for him on June 20, 1905.

James Henrie, Joseph's brother, who also ranched near Leigh, Idaho, north of Leigh Creek, met Elijah Canary at his brother Joseph's ranch, on the Idaho side of the Teton Basin. When questioned about the last time he had seen Canary, James Henrie replied the date was June 27. Canary was "coming down the south side of my place with a brother of mine." John, the brother with Canary, told him they were going to Bitch Creek, which was only about five miles from James's ranch. John and Elijah had a team, some hay and chains and were leading a pony with a saddle on it behind the wagon. John told his brother James that they were "going after lumber and that they were going to stay all night." Elijah made no response to the conversation. When asked when John returned, James replied that it was two weeks before he saw John again. He did not see Elijah return and had not seen the pony and saddle since.

According to further testimonies, Elijah had later ridden into the Archibald Nebeker ranch in Star Valley near Fairview, Wyoming, leading a black gelding with white markings on the face and a *B* branded on its left shoulder.

Nebeker farmed and raised stock in Fairview, Wyoming. On July 10, according to Nebeker's testimony, Elijah came by his ranch to transact business. Elijah had brought the black gelding to him and wanted to trade for a black three-year-old filly. He wanted ten dollars to boot, and Nebeker wouldn't trade. Elijah then reduced his price to five dollars, but Nebeker still wouldn't trade, telling Elijah he would do an even trade. Elijah accepted but asked if Nebeker would keep the mare until fall. Nebeker told him no.

Archibald Nebeker had known of Elijah for fifteen years and probably was aware of Elijah's reputation for stolen horses, so he asked him a few questions. Nebeker asked Canary if the horse got away from him where would the animal go. Canary said he would go to Rich County and that the horse was raised on Bear River.

Nebeker had formerly lived in Laketon (Laketown), Rich County, Utah, near Bear Lake, which straddled the border of southern Idaho and northern Utah in northeastern Utah. If he knew of Elijah for fifteen years, it would indicate Elijah had been in the area of southern Idaho, northern Utah and western Wyoming for the last fifteen years, dating back to 1889. But several of those years he served time at the Laramie prison.

Satisfied with the information, Nebeker let him choose a horse. Nebeker wrote out a bill of sale at the corral for the animal, and Canary signed it. Nebeker and Elijah ran the mare in, but when they tried to catch her, she jumped the fence. The trade wasn't going well. Elijah told Nebeker that he was in a hurry to see Mr. Baliney and that he would come back the next day and get the mare. Nebeker said he hadn't seen him since.

Nebeker kept the horse about a month, but when Mr. Severson, the rightful owner, came to him and claimed the animal, he released the mare.

After the depositions, Judge Donaldson, the probate judge, certified that the depositions were taken before him in open court, "each question being asked. The true answer given, by each of the witness was duly recorded and the deposition of each witness was duly signed in my presence this 26th day of August in the Probate Court of Freemont County—State of Idaho A.D. 1905 John Donaldson Probate."

Satisfied that Elijah was guilty, Donaldson set bond on August 26, 1905. The bond was fixed at $750, and Elijah was committed to the custody of the sheriff.

County attorney O.P. Soule filed a complaint on October 12, 1905, stating that on or about July 1, 1905, John A. Henrie, also known as Jack, committed the crime of grand larceny in the manner following: "Did willfully, unlawfully and feloniously steal, take, lead, drive and carry way three head of horses then and there being the personal property of Peter S. Johnson, Byrum Severson, William J. Hanson and James G. Johnston, co-partners under the firm name and style of Johnston, Severson and Company."[279]

Ten days later, on October 24, 1905, John A. Henrie was brought into court. John Donaldson noted that the defendant waivered preliminary examination. John Henrie was charged with grand larceny, and bail was set at $750. He was then committed to the custody of the sheriff of Freemont County.

1156. — STATE PENITENTIARY, BOISE, IDAHO.

Elijah served a one-year sentence at the Boise prison in 1905 for stealing three horses in Idaho. *Author's collection.*

Because of his horse-stealing escapade, Elijah Canary, aged thirty-eight, was admitted to the Idaho penitentiary in Boise, Idaho, for grand larceny on November 30, 1905. A Boise newspaper, the *Idaho Daily Statesman*, made note of this, entitling its report "New Prisoners at the Pen." "Two new prisoners were received yesterday at the state penitentiary making a grand total of 204 inmates of that institution. The latest two were brought in from Fremont County…They are Eliza [Elijah] Canary and John A. Henrie."[280]

The *Teton Peak-Chronicle* of St. Anthony, Freemont County, Idaho, published the district court proceedings regarding *State v. Elijah Canary*, reporting that Elijah Canary pled guilty to grand larceny and was sentenced to one year in the penitentiary with hard labor.[281]

At the time of admittance to the Boise prison, Elijah gave his personal information. He stated his legitimate occupation was ranching. He was divorced from his wife at the time and indicated he had one child. Elijah remained true to his version of birth information, stating he was born in Helena, Montana, to a father who died when he was six and to a mother who died when he was an infant. He admitted to little religious instruction, was a moderate drinker and could read and write.[282]

Most importantly, Elijah indicated his nearest relative was a cousin, Milt Canary, who lived in Weiser, Idaho.

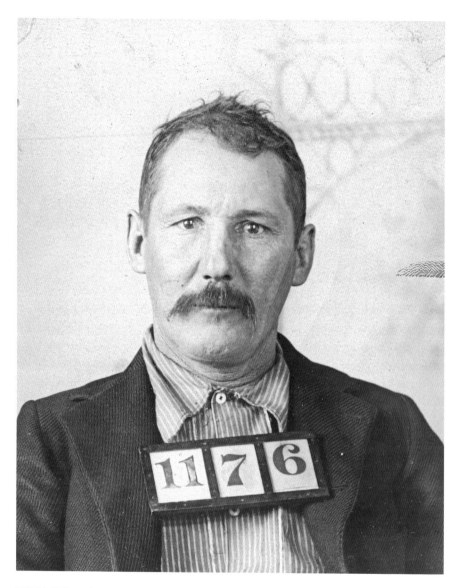

Elijah's Boise prison mug shot, circa 1905. He made his court appearance in St. Anthony, Idaho. *Idaho State Archives.*

Since Milt came west much later than his cousin Elijah or his uncle Robert Canary and the rest of the family, one wonders where Elijah learned of Milt Canary's whereabouts.

11
CANARY RELATIVES

Where Elijah went after he left the Boise prison on October 30, 1906, is mere conjecture. Could he have gone to visit his cousin Milt? Milt Canary, known in official records as James M. (Milton) Canary, lived in Weiser, Idaho, at the time of Elijah's incarceration. This invites further examination.

Milt was born in Ohio in 1851 to James Thornton and Delilah Canary. James T. was the brother of Robert Canary, Elijah's father. The 1870 census indicated that Milt was living with his family, a mother and father and six siblings, in Medicine, Mercer County, Missouri. The post office was located in Princeton, near where Elijah's family originated. Both families had lived in Mercer County.[283]

Robert Canary and his family left Missouri in 1865, but the 1880 census confirms that James Thornton's side of the family was still living in Missouri. George, aged twenty, worked in a sawmill. James Milton was twenty-seven years old and was teaching.[284]

Some of the Canary family from Missouri arrived in Idaho by wagon train in 1881, but James Thornton; his wife, Delilah; and their grown children came west in 1882 with another wagon train. Milt was thirty-one and the youngest child in the family was seventeen when they made the overland journey. The Canary families settled in or near Middle Valley, later known as Midvale.[285]

Milt was nearly a decade older than Elijah, so it is doubtful that young Elijah would have remembered him from Missouri, but they may have

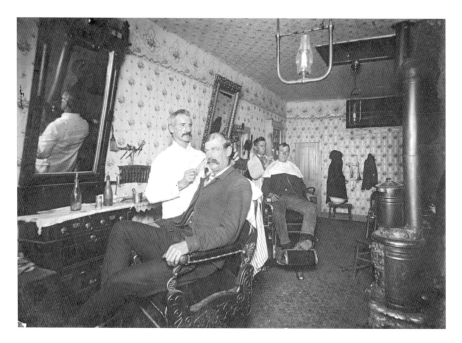

Elijah's cousin Milt Canary is pictured as the barber beside the front chair at a Weiser, Idaho, barbershop. *Snake River Heritage Center Museum.*

reconnected in Idaho. Elijah knowing his whereabouts and referring to him by his shortened middle name may indicate familiarity.

James Milton Canary began his early Idaho years as a postmaster and teacher in Middle Valley. He was listed as a teacher in attendance at the first teacher's institute on November 10, 1883, in Washington County, Idaho. The community thought favorably of him, describing him as "a young man of good habits."[286]

Prominent in community affairs, James Milton was nominated on the Republican ticket to run for assessor as early as 1884. He won by a slim margin. He served as county assessor from 1896 to 1898 and as treasurer from 1904 to 1906 in Washington County. Besides these duties, James Milton worked as a barber, a business he was engaged in for many years.[287]

Occasionally, the Weiser and Midvale newspapers carried stories of the Canary family. One such story was of a fire that consumed James Thornton and Delilah's Canary home in Middle Valley in November 1887. Thought to have been started by a grandchild, the fire consumed their home and all their possessions. James Milton was living with his parents at the time, for the news item mentioned him as their county assessor and collector. He, too, lost all his clothing, currency, books and papers.[288]

Lizzie Cope is pictured either to the left or right of Pastor L.L. Shearer, standing to the right of the double doors of Weiser Baptist Church, circa 1885. *Snake River Heritage Center Museum.*

A year before, Milton ran an ad in the paper in search of his right French calf boot, size eight and a half, lost between the Indian Valley post office and Joseph York's place. If found, the finder would be compensated and was to leave the boot at the Middle Valley post office.[289]

While Elijah was in the Laramie prison, cousin Milt married Lizzie Cope, who was twenty years younger than him. Pastor Charles W. Luck married the couple on September 26, 1899, in Weiser, Idaho. Emma Cope and B.F. Cope were their witnesses.[290]

The couple wasn't even married a decade before Milt died on February 13, 1909, at age fifty-seven after fourteen weeks of fever.[291]

Milt's obituary described James Milton Canary as a "good friend and citizen, and held in high esteem by all who knew him. He was one of the best known citizens of this city and county where he had resided for so long."[292]

The newspaper stated:

> *Out of respect for the deceased all the shops were closed and the barbers attended the funeral, which was one of the largest held in Weiser. The floral tributes were many and beautiful. The ladies of the Women's Relief*

Corps, of which Mrs. Canary is an honored member, attended the funeral in a body.

The newspaper praised Methodist pastor Reverend W.W. Deal, who presided over the funeral, adding that he "paid a splendid tribute to the deceased."

James Milton and his wife had no children, but he was survived by his wife, three sisters and two brothers. Lizzie continued to take in boarders, just as she and her husband had when they were married.[293]

Elijah may have attended his cousin's funeral and may have been living with or near his relatives after his release from prison after August 1906. Boise, Idaho, where he was incarcerated, was in proximity to his uncle James Thornton and some of his cousins who had settled near Midvale, Idaho. The 1900 census indicated that his Uncle James Thornton and Aunt Delilah were living with their youngest daughter, Lanis, and son-in-law Gay L. Killian in Washington County, Idaho.[294]

Milt's parents were also held in high esteem. In July 1900, Elijah's Uncle James Thornton Canary died at his home. His obituary acknowledged that he was highly respected in "this city…He was the original owner of the Middle Valley [Midvale] townsite and was closely identified with the history of that section." Delilah, referred to affectionately as Grandma Canary, died in February 1908 at the age of eighty-six. She was "loved and respected by all."[295]

The 1910 census reported that James M. Canary's brother George also lived in Midvale for a time. He was fifty years-old; his wife, Elnora, was thirty-five. By 1920, George and Elnora were living in Spokane, Washington.[296]

Perhaps Elijah connected with these relatives through his sister Calamity. Calamity did indicate in her autobiography that she made visits to Idaho after 1893, and perhaps she visited with them sometime before.

If Delilah met Calamity in Idaho, she probably rolled her eyes and exclaimed to her husband, "Like mother, like daughter!" The stories about Charlotte Canary and Robert Canary circulating in Mercer County, Missouri, were not flattering.[297]

In order to protect their own reputation as upstanding citizens and perhaps out of shame of the wayward relatives, it is not unusual that the Canary obituaries do not mention their relationship to Calamity Jane. Even as late as 1970, their descendants avoided discussing their infamous relations. Obviously, they didn't want to be connected.[298]

It's unclear how the Canary relatives felt about Elijah, but it appears he may have looked them up after being released from the Boise prison. The

1910 census places Elijah Canary in Oregon, working on a sheep ranch near Bully Creek, Oregon, in Malheur County. At first glance, this Elijah does not appear to be Calamity's brother. The age of this Elijah is younger than he should have been, and Oregon was recorded as his birthplace, not Montana, but it's possible he wanted to seem younger than he was. He was listed as a hired man, living with seven other hired men, presumably in a house.[299]

Another clue that this is Calamity's brother is the location of the sheep ranch. Elijah's workplace on Bully Creek, near the town of Westfall, was just a short distance across the Idaho border from his relatives. Although James Milton had died a year before the 1910 census, Elijah may have had contact with him originally and may still have been in contact with Gay and Lanis Kilborn, his cousin, who lived nearby in Midvale, Idaho, or his other cousin George, who was also living in Midvale.[300]

How long Elijah lived here is not known, however, an illustrated article written by a schoolteacher who came to nearby Westfall to teach in 1907–8 includes a photograph of sheep shearers at work on a sheep ranch not far

Sheep shearers in Malheur County, Oregon, 1907–8. The man to the right forefront resembles Elijah Canary. Photographer Lucy Adams. *Oregon Historical Society, image no. bb013420.*

from Westfall. The short man in the photograph resembles Elijah Canary's Boise prison mugshot. If this indeed is a snapshot of Elijah, this revelation would place him working at the sheep ranch as early as 1907. Herding sheep seems unlikely, considering his past occupations, although he may have had experience working with sheep while he lived in Wyoming, and perhaps he didn't have any other choice.[301]

If Elijah chose to work in the Bully Creek area, he would have encountered a desolate environment. Sagebrush covered the arid area surrounding Westfall; barren mountains loomed in the distance. Schoolteacher Lucy Sophia (Adams) Ransom, who had taught in Westfall for a term in 1907–8, described the land as "incredibly ugly," devoid of grass as far as she could see. Sheep and cattle ranches sprawled across the desolation, cheerfully interrupted with patches of green, irrigated alfalfa fields. Cattle were fed from large alfalfa stacks, while sheep were herded in the distant mountains.

Incorporated in 1895, Westfall, located near the northern rim of Cottonwood Valley on Bull Creek, was a small town of clapboard dwellings inhabited by about 140 inhabitants, with one hotel classified as the "finest hotel anywhere this side of Boise." Built in the Queen Anne style with twenty-two rooms, sixteen of which were luxurious sleeping quarters, the large hotel offered lodging to those traveling. The hotel was a regular relay and eating station on the stagecoach run from Vale to Burns. Lucy traveled thirty-one miles of this road to come to Westfall, commenting that it was the "dustiest road I ever traveled." She survived the "suffocating clouds of yellow dust" by hiding her face behind a veil or covering her nose with a "grimy" handkerchief.

By 1903, the desolate Westfall had become an important trading center. "A rough-hewn plank, barnlike" mercantile stood on Main Street. A high platform built near the building's entrance enabled freight wagons to load and unload easily. Its warehouses were located on the side streets. Not far from this store, another general merchandise store had recently opened. According to Lucy, both were prospering and contained everything one would want to buy. Two saloons and a dance hall provided limited entertainment. In spite of its dreariness, the town's people were optimistic that the railroad would bring additional prosperity to their town.[302]

Elijah apparently grew tired of sheep and left Westfall. In 1913, Elijah's name appeared in a Wyoming newspaper regarding an incident in the Mormon town of Afton in Star Valley, Wyoming, six miles from the Idaho border. James H. Poorman, known as Hud, and Elijah Canary were arrested

THE SAGA OF LENA AND ELIJAH CANARY

On the Idaho and Wyoming border, Afton, Wyoming, became a popular place to play cat and mouse with the law. *Author's collection.*

for being intoxicated and were brought to trial in Justice Thomas Wilde's court. Attorney Austin of Montpelier represented the defendants who,

> *giving a lengthy plea, trying to impress the court that our town ordinance relative to the charge would prove annul and void if taken to higher court, and also, that our police officers were unqualified. The court room was filled with a large assemblage eager to learn the outcome…it was recommended that the case be demurred on account of the arrest being illegally made in compliance with the ordinance.*[303]

Like Elijah, Poorman had his share of difficulties. Hud had been in trouble with the law and had been imprisoned like Elijah had. Seemingly, both Elijah and Hud had a lot to talk about over a few too many drinks.

Hud who was a rancher living in Auburn, Wyoming, with his wife, Rebecca, where the little rock church frequented by outlaws was located, had met up with someone who influenced him to break the law.

Hud Poorman was a well-known cattleman who was charged with embezzlement of $2,194 from the Grovant Cattle Company in 1904. While on a big drive in Omaha, Poorman spent the money, which he was unable to replace. He subsequently served a term in the state penitentiary.[304]

119

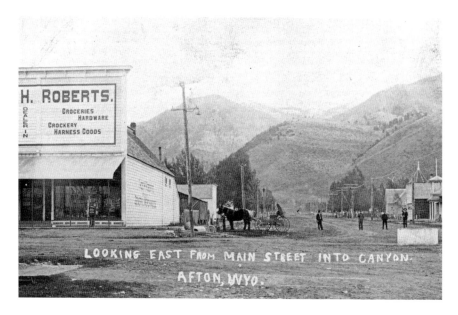

Outlaws and polygamists hid out in Afton, Star Valley, Wyoming. Elijah was arrested for intoxication in this town. *Author's collection.*

Once arrested, seeking a pardon seemed to be a natural course of action for outlaws. The *Wyoming Tribune* announced on December 1904 that Poorman was seeking a pardon. Part of the reason may have been that he was going blind. The newspaper stated, "A petition will be filed with Governor Chatterton in a few days asking for the pardon of Hud Poorman, serving a term in the state penitentiary at Rawlins for a crime committed in Uinta County."[305]

The newspaper seemed rueful when Hud fell into bad circumstances with the law, reminding its readers that he was one of the men who had helped capture Jim McCloud. McCloud had aided Tom Horn in a jail break in August 16, 1903. McCloud, who was confined to a neighboring cell, assisted Tom Horn in overpowering Deputy Sheriff Proctor, taking his keys and escaping. Hud Poorman was one of the men who caught them within a half hour of the escape. McCloud had robbed a Buffalo post office and was awaiting trial.[306]

When Poorman was released from prison on Christmas Day 1905, the *Star Valley Independent* noted the return of one of its own: "Hud Poorman returned to the valley last Wednesday night from Rawlins, having been granted full pardon by the Governor." It's not surprising that the valley welcomed him back. The Star Valley citizens banded together, whether they were outlaws or not. They supported one another without question. Perhaps this is why Elijah spent so much time in the area.[307]

SWAN VALLEY

Named for the swans that grace the landscape during winter and spring, Idaho's Swan Valley is a beautiful region framed with forested mountains. Rivers and creeks distribute the snows and rains that water the verdant valley. It is here where we find Elijah, sometime before 1920.

Additional information concerning Elijah has trickled down from his cousins. Elijah's cousins also believed he was buried in Irwin, Idaho, which is thirty-three miles south of Freedom, indicating Elijah may have had some connection with the area of Irwin, also.[308]

Irwin, located in Bonneville County, is north of where Calamity and Steers were married in 1888 in Pocatello, Idaho, and where Calamity and Steers were living at the time of their marriage. It appears to be more than coincidence that some of the Canary siblings were possibly occupying the same area for a period of time. Since Calamity was in the vicinity, she may have had the opportunity to visit her brother.

Several people from Swan Valley have passed down stories about when Elijah was living in the valley. A letter written by Juanda Daniels Whisman to Doris Sermon sheds light on Elijah's whereabouts from about 1914 to 1917. Although her remembrances of Elijah originate with her parents, it identifies where Elijah was during this period.[309]

Juanda Daniels was born in Irwin, Idaho, on June 23, 1916, to Dora and Ed Daniels. Dora, who was christened Doris Belle Jacobson, married William Edward Daniels on October 19, 1915. Ed's family, the J.R. Daniels family, arrived in the valley in 1891. J.R. Daniels built a two-story house

Elijah lived in a dugout in Swan Valley, Idaho, for a few years and then mysteriously disappeared. *Author's collection.*

Elijah Canary was familiar with Snake River Canyon near Jackson and Alpine, Wyoming. *Author's collection.*

in Irwin, where he and his wife, Lydia, raised a large family. Ed played the fiddle at local dances while his wife told stories of the old days that made her audiences laugh. Eventually, they would own a ranch on the West Bank of the Snake River near Papoose Creek.[310]

Juanda recalled from family stories that Elijah Canary trudged into Swan Valley one day about 1914 or 1915. The day Elijah entered the valley, the posse was close on his heels. Elijah swam the stolen horses across the mouth of Grays River. The horse that Elijah was riding became overheated from the fast pace down the canyon and fell dead. Elijah jerked the saddle from the horse and packed it over his shoulder into the valley. Ordinarily, he could have crossed on the John Booth Ferry a few miles down the Snake River at Alpine, Wyoming, but the posse was on his tail.

The Daniels family eventually befriended Elijah and referred to him as Lydes. Sometime later, the Daniels family learned that he was with a horse thief gang that was stealing horses in South Dakota and bringing them into Jackson Hole. Lydes Canary, in the company of Jeff Clark, brought them into the Salt River Valley, which was also referred to as Star Valley. From there, more riders would take them to Salt Lake City and sell them in the area. They would also ship them on the train from Salt Lake.

Elijah remained in Swan Valley for a time and became friendly not only with the Daniels family but with Juanda's uncle Lewis Daniels as well. Lewis Daniels worked as a ranger in the local Targhee and Caribou Forests. Lewis may have named Canary Canyon, located in the vicinity, in his honor.

In November 1916, Ed Daniels packed his young wife, Dora, and four-month-old Juanda into a sheep camp wagon and traveled from the Ralph Flemming place toward the Snake River from the Swan Valley Store. Ed fed 1,600 sheep for Jesse Wheat and was hauling hay all over Swan Valley. His wife, Dora, drove the horses while he threw the hay to the sheep. That winter, the snow was over the tops of the fences, and the temperature was miserable at fifty degrees below zero for several days. They lived there until after Juanda was nine months old, and she learned to walk in the sheep wagon.

Lydes Canary liked Ed, as well as Dora's cooking, so he would come over from Swan Valley and eat supper with them. Juanda wrote in a letter, "I always tell people that is my only claim to fame." Lydes Canary would play with Juanda while Dora cooked supper. By the end of the winter of 1917, the hay was all used up in the valley, and the sheep had to be trailed to the valley near Ririe, Idaho. Uncle Lewis Daniels was hired to help and so was Lydes. The snow was deep, preventing them from getting very far the first day. They spent the night at the homestead of Jeff Clark, the horse-stealing

friend of Lydes. Elijah and he were happy to see each other once more and visited all night, saying they would never go to Wyoming; the people there would hang them. Juanda wrote that Lydes never came back to the valley. "I think Uncle Lewis knew where he went. But he is dead and so is my father."[311]

Interestingly, Dora Daniels made a lasting impression on Swan Valley's history and its people. Known affectionately as Aunt Dora, she lived to be almost 105 years old. She was honored in 1987 as Pioneer of the Year from Bonneville County. She told stories of Idaho's history, entertaining people for hours. She told jokes, recited poems, sang songs and even danced a jig to prove she was still young. After her husband's death, she lived alone in their home near the forest. The couple never tore down their original homestead cabin. She still used it to celebrate important holidays in her original cabin. She owned a citizen-band radio to keep in touch with the world and often gave advice and weather reports to truck drivers, who gave her the moniker "West-bank Wildcat."[312]

Juanda's letter indicates that Elijah perhaps never gave up his life of theft and that he was indeed living in the area near Irwin, Idaho, which is located in the Swan Valley, like his relatives said he had. And, perhaps, Dora lightened his mood and made Elijah laugh for a while.

Other local Swan Valley residents have passed down several stories concerning Elijah's stay in the valley. Elijah was said to have had a girlfriend in nearby Alpine. Who she was, no one remembers.[313]

Archie McKay remembered a "hermit man" living in a dugout in the mountain near Palisades Creek. He said he was then a kid riding with his dad when they went to this dugout, and Mr. Canary invited them to stay for biscuits and coffee. Archie remembered hesitating about going in and wanted to stay on his horse, but Elijah prodded him, "Are you old enough to drink coffee?" he asked. With that invitation, Archie's father told him to get off the horse. Archie's father had befriended Elijah. Even though, he admitted, Elijah was a "dirty hermit, he had a heart of gold."[314]

Elijah was baking biscuits and they smelled so good, Archie said. He also observed that the dugout and Elijah were very dirty. The McKays didn't live that way, and Archie wasn't so sure he wanted to eat or drink anything. Archie also remembered there were spaces dug out to put things in, and Mr. Canary got a jar of wild honey from one of these places for the biscuits. "Everything looked 'wild' in that dugout," Archie recalled. Mice were running around, and Elijah told his guests not to pay attention to them as they were his friends. Later, a rat popped out of hiding, and Elijah again wasn't concerned and commented, "He's just checking out my friends," he

Palisades Creek is located in Swan Valley, where Elijah lived in a dugout. *Author's collection.*

assured them. The biscuits were delicious, but Archie wasn't so sure about their cleanliness. Seeing the mice running free range made him wonder.[315]

Archie said Mr. Canary had a nickname of Lige and that he was almost blind. Coincidently, Elijah's sister Lena also suffered from blindness in one eye. Archie's father told him that he didn't know anything about Elijah, as he was closemouthed about his life.[316]

Archie said later in his life that a man by the name of Henry Canary worked for him for a short period of time; he didn't know if the two were brothers or not. When Elijah left the country without telling anyone where he was going, the McKays were concerned for his welfare.[317]

Interestingly, Nancy Wilson Ross wrote of a half-blind hermit who lived in a dugout in Idaho. According to Ross in her book *Westward the Women*, a half-blind hermit who sang ballads and lived near the Golden Anchor Mine visited about Calamity's sister as if he had known her. Ross wrote a sketchy account in her book:

> *Another famous Idaho character whose respectable married name is best left unmentioned is said to have been a sister of Calamity Jane...This statement is sworn to by the ballad-singing, half-blind hermit who lives near the Golden Anchor mine alone with his memories...This old man bases his assertion on his remembrance of the night he saw Calamity Jane's brother going down to a dance hall—whether in Deadwood Gulch, Blackfoot, or Virginia City he did not say-to shoot his young sister because she was "turnin' out bad"...This sister, if such she was, had another name before her Idaho one. It was, says the hermit of Golden Anchor, Lousy Liz.*[318]

The fact that there was a Thunder Mountain mining boom in central Idaho lends some support to the meager story. Promoted by the Oregon Short Line Railroad, the boom occurred in the late 1890s and early 1900s. The Cheyenne newspaper advised the public not to go there, as it wasn't worthwhile. Free gold was panned, but not in large quantities, and it was only found in one stream. The richness of the placers had been exaggerated, the newspaper warned.[319]

Golden Anchor, one of the Marshall Lake Mines, was discovered in 1915. Information about Elijah is missing during 1915, therefore, it's feasible that Elijah could have been the hermit living in a dugout in the area during this time. He may not have wanted to identify himself as the brother who was going to shoot his sister.[320] Furthermore, Elijah fits the description of the hermit. He was going blind and had possibly inherited the same genetic

debility of blindness his sister Lena had suffered in one of her eyes. And he had not aged gracefully. Records indicate he had bad teeth by the time he was forty. At the time of the interview, he could have lost most of his teeth, making him appear older than he really was.

This account of a sister "turnin' out bad" smacks of another story with similar details.

Black Hill pioneers Jesse Brown and A.M. Willard wrote a vague account involving Calamity and one of her unnamed brothers:

> *For a time she* [Calamity Jane] *was an inmate of a resort in Green River, Wyoming, from which place her brother ran her off at the point of a gun, taking several shots at her by way of good notice. The brother later passed out of notice when the gold rush to the Hills took place.*[321]

According to the newspapers, Calamity frequented Green River several times over her lifetime. Founded in 1868, Green River would become one of her favorite haunts. The brother mentioned would have to have been Elijah, who would accompany her to the Black Hills with the Newton-Jenney Expedition in 1875.

It is odd that Elijah would be reprimanding two different sisters at the point of a gun. Was he the self-appointed enforcer of his sisters' moral codes?

THE DOXFORDS

Although records do not confirm Elijah's whereabouts immediately after Boise prison, it is certain Elijah's former wife, Kate (sometimes spelled Katherine or Catherine), remarried on July 21, 1906, in Ely, Nevada, to Aaron Doxford.[322]

The Doxfords were a well-established Mormon family from Monroe, Utah. Aaron's father, Robert, sailed from England in 1860 with his father, Joseph, and a brother to America, where Aaron's grandfather Joseph was needed for missionary work for the LDS Church. After they saved enough money, the rest of the family joined them. Aaron, who was named for his maternal grandfather, grew up on a farm in the Monroe, Utah area.[323]

According to the 1910 census, Kate and Aaron were still residing in East Ely, Nevada, where Aaron was employed mining copper. At that time, the Ely district was the most highly productive mining region in Nevada. Trains transported the ore through Ely to the McGill refinery. A relative, Mont Carson, who would be listed as a well-regarded family member in Kate's father's obituary, also lived in Nevada at McGill and worked in mining as a concentrator electrician. The McGill smelter was the first large copper smelter built near the newly completed Nevada Northern Railroad to treat concentrates.[324]

Aaron was twenty-seven and Kate was thirty years old in 1910. Living with them were Kate and Elijah's son Frank, aged thirteen, and Kate's sister Esther Carson, aged sixteen.[325]

At some time, the Doxfords moved to Panguitch, Utah, founded by the Mormon pioneers in 1864. The settlement, named for the Paiute word for

"big fish," is situated at the south end of Panguitch Valley near the north slope of nearby mountains and surrounded by the scenic beauty of red sandstone cliffs and mesas. The town site was laid out in a grid pattern typical of a Mormon town, encouraging a cohesive community as opposed to isolated farmsteads. Each residential lot was large enough to accommodate gardens and a few animals to encourage self-sufficiency.[326]

The Doxford family came to this semi-rural place, where Aaron and Frank found jobs as carpenters, helping to build some of the beautiful red brick homes and buildings that have been preserved to this day, known as the Panguitch's Historic District. The bricks, made in Panguitch, dominated the building scene from 1875 to 1940 when the Doxfords lived there.[327]

Tragically, Frank would leave this earth far too young. He passed away unexpectedly on April 19, 1916, in Panguitch, Utah, where he was living with Aaron and his mother, Kate. He died of a ruptured appendicitis at the age of nineteen. Aaron Doxford signed as informant on Frank's death certificate, indicating Aaron had taken on the responsibilities of a natural father.[328] Aaron apparently regarded Frank as his son, as the following obituary intimates:

Frank Canary, only son of Mr. and Mrs. Aaron Doxford was born in Ogden, Utah, July 9, 1896, and died at their home in Panguitch, Utah, April 19, 1916, aged nineteen years, nine months, and ten days. Frank was a happy, light hearted boy and won a warm place in the heart of his many friends. In his home he was sunshine and joy to the parents and grandmother. During the ten days of his terrible suffering he was even thoughtful of those who cared for him; to the last appreciative for every effort to relieve his pain. He was taken to the home beyond, just as he was budding late manhood, with all prospects for a bright and useful future. In that Heavenly Home his many graces will be multiplied. Death held no horrors for Frank, for he placed his trust in the One who conquered Death and the Grave that Eastertide so many centuries ago. A slight modification of Bryant's lines are well fitting: He went not like a quarry slave at night, Scoured to his dungeon; But sustained and smoothed by an unfaltering trust approached his grave like one who wraps the drapery of his couch about him, and he lies down to pleasant dreams. Appropriate funeral services were conducted by Rev. T. M. Keusseff accompanied by fitting remarks by Mr. Riding. The body was laid to rest in Panguitch Cemetery to await the morn of Resurrection. To the father who watched so faithfully through the long hours of suffering, to the mother whose heart longings were over hovering

over him and to the grandmother who responded so lovingly to his every call, may the Lord who giveth and taketh away, give you grace to commit him to the care of the Good Shepherd to await your coming.

A Friend[329]

Not surprisingly, Elijah is not mentioned, nor would he have been informed of his son Frank's untimely death. Elijah was probably living in seclusion at Swan Valley, Idaho, at the time.

Interestingly, Reverend T.M. Keusseff, who presided over the funeral, established a Presbyterian church, the first non-Mormon church, in Panguitch, meaning that Frank may have not been a Mormon like his adoptive father.[330]

Apparently, Frank used the surname Canary and Doxford interchangeably, as evident when the Panguitch newspaper mentioned a couple in attendance: "Mr. and Mrs. John E. Hays of Salt Lake City were here to attend the funeral of Mr. Frank Doxford."[331]

A tender thank-you from the Doxfords and grandmother Irene Carson appeared in the newspaper:

We wish to express our heart felt thanks for the kind and loving sympathy tendered us by the thoughtful men, gentle women, kind young people, and dear little children of Panguitch, during the recent illness and the passing away of our son and grandson. Mr. and Mrs. A. Doxford and Mrs. I.J. Carson.[332]

In spite of the devastating loss, Aaron continued his carpentry business. One newspaper article attributed a building project to Aaron and furnishes us a clue about his workmanship. "Messrs. Johnson and Doxford are getting the handsome new dwelling of Mr. Burns Tebbs nearly completed." The new dwelling the newspaper referred to was located on 190 North Main, being a bungalow-type dwelling of the Arts and Crafts style.[333]

Fortunately, the house owned by Mr. Burns Tebbs remains standing today, a testimony to Aaron's fine craftsmanship. A well-regarded member of the town, Burns Tebbs owned a ranch on the road to Panguitch Lake, and he had one built in town, too. He and his wife, Ruth, were industrious and took in boarders. Their names often appeared in the local news. Many of the ranchers in the area owned two dwellings, one in the country for the summer and one in town to be used in the winter.[334]

Aaron and Kate remained in Panguitch until January or February 1918, when they left for Bakersfield, California. Perhaps memories of

Elijah's son, Frank Elijah Canary, died in Panguitch, Utah, and was buried in the Panquitch Cemetery. The grave is unmarked. *Author's collection.*

Frank weighed heavily in their memories. Kate's mother, Irene, left with them.

The couples' residency in Bakersfield didn't last long. Ten months after their move from Panguitch, Aaron and Kate succumbed to the dreaded Spanish influenza that was sweeping the country at the time. Aaron died of influenza in October 1918. Kate followed in death at the age of thirty-eight four days later on November 2, 1918. The name on her death certificate is listed as Catherine E. Doxford. Kate's mother was left alone and must have been devastated at losing both daughter and son-in-law.[335]

The newspaper reported the tragedy under an incorrect surname:

> *For the second time within three days the grim reaper has called at the Oxford [Doxford] home, twenty-seventy and H Streets. Mrs. Katherine Oxford was called in death this morning. Mrs. Oxford's husband Aaron Oxford was buried yesterday. The body is at the undertaking parlors of Payne and O'Meara, pending funeral arrangements.[336]*

At some time, Elijah must have learned of Kate's death, for on his own death certificate, he is identified as a widower.

CALAMITY JANE AND HER SIBLINGS

After living in Swan Valley for a time, Elijah withdrew to Roosevelt, Utah, where he led a life as a laborer. The snowcapped Uinta Mountains rise to the north of Roosevelt, platted in 1906 and located seven miles west of the Uintah River.

Sadly, his death certificate was written without an informant. However, somewhere, someone confirmed that his birth year was July 1, 1862, and his birth place was Montana. No one could testify how long he had been a resident or why he left Swan Valley. Was he hiding from the law once again?

Elijah's death certificate indicated he was a laborer and was working on a farm at the time of his death. If Elijah worked on a farm or ranch near Roosevelt in 1920–21, he surely found life difficult. In the 1920s, grasshoppers were so entrenched in the area that the county issued a bounty on grasshoppers, one cent per pound.

Furthermore, the local newspaper seemingly didn't print a word about his death from chronic myocarditis (infection of the heart muscle) on October 20, 1922, at the age of sixty.[337]

He was buried in the Roosevelt Cemetery in Roosevelt, Utah, in the potter's field, a small corner section of the cemetery. There probably was

Elijah Canary was buried in the potter's field in this cemetery in Roosevelt, Utah, in 1922. The grave is unmarked. *Author's collection.*

no funeral, no eulogies, no flowers, no obituaries and, perhaps, no one to mourn his passing.

A large red butte looming in the background, separated by a highway, overlooks his unmarked grave.

Why Elijah chose Roosevelt, Utah, to reside is a mystery. But perhaps he was reminded of the old days while living there. The pounding hoof beats from outlaws on the run still reverberated from memory on the Outlaw Trail. Roosevelt wasn't far from the town of Vernal to the north, where outlaws came out of hiding to purchase supplies. Brown's Hole was nearby to the east, where outlaws had hidden out a few decades earlier. And then there was Robbers' Roost to the south.

Possibly by now, Elijah had said goodbye to the freedom and lawlessness of the West that he and his sister Martha had reveled in. Both had paid the price for the thrills and bold adventures of those frontier days. Martha became a legend, Lena a wife and mother and Elijah an outlaw on the run.

NOTES

Chapter 1

1. *Life and Adventures of Calamity Jane.*
2. Ibid.
3. Ibid.
4. *Mercer County Pioneer Traces*, 150. Entry written by Elva Pratt Douthat, the granddaughter of Candace Canary, daughter of James Thorton Canary. Courtesy of an e-mail from William Whiteside.
5. *Basin Republican Rustler*, September 18, 1941. Originally appeared in the *Lander State Journal.*
6. Ibid.
7. McLaird, *Calamity Jane*, 13.
8. *Mercer County Pioneer Traces*, 150.
9. Etulain, *Calamity Jane*, 110.
10. *Basin Republican Rustler*, September 18, 1941.
11. *Montana Post*, December 31, 1864.
12. Ibid.
13. Ibid.
14. McLaird, *Calamity Jane*, 17–18.
15. Ancestry.com.
16. Geni.com. There is no record of Elizabeth Burge's death.
17. Ancestry.com.; familysearch.org; geni.com.
18. Ibid.
19. Utah death records.

20. Idaho State Historical Society; Wyoming State Archives.

21. *Mercer County Pioneer Traces*, 150.

22. *Life and Adventures of Calamity Jane.*

23. McLaird, *Calamity Jane*, 23.

24. *Uinta Chieftain*, November 14, 1885.

25. Whiteside, unpublished notes.

26. *Omaha World Herald*, January 25, 1954.

CHAPTER 2

27. Sherlock, *South Pass and Its Tales*, iii.

28. Ibid.

29. Lindmier and Georgen, *South Pass City*, 22–36.

30. *Basin Republican Rustler*, September 18, 1941.

31. Ibid.

32. *Wyoming Wind River Mountaineer*, "Pioneer Profiles," 2, 32–33.

33. Sherlock, *South Pass and Its Tales*, 43.

34. Ibid., iii, 74.

35. *Basin Republican Rustler*, September 14, 1941.

36. Sherlock, *South Pass and Its Tales*, iii.

37. *Basin Republican Rustler*, September 14, 1941.

38. Ibid.

39. *Wyoming State Journal*, December 30, 1962.

40. Ibid.

41. *Wyoming Wind River Mountaineer*, "Pioneer Profiles"; *Wyoming State Journal*, December 30, 1962.

42. *Wyoming State Journal*, December 30, 1962.

43. *Wyoming Wind River Mountaineer*, "Pioneer Profiles."

44. *Basin Republican Rustler*, September 14, 1941.

45. Ibid.

46. Mathisen, "Calamity's Sister."

47. *Basin Republican Rustler*, September 14, 1941.

48. Wyomingtrailsandtales.com.

49. Ibid.

50. *Omaha World Herald*, January 25, 1954.

51. Loveland, "Greybull, the Town," 1.

52. *Wyoming Wind River Mountaineer*, "Pioneer Profiles."

53. *Basin Republican Rustler*, September 14, 1941.

Chapter 3

54. Young, *Hard Knocks*, 171–72.
55. *Life and Adventures of Calamity Jane.*
56. Whiteside, unpublished notes; *Chicago Tribune*, June 19, 1875.
57. Ibid.
58. *Cheyenne Daily Leader*, February 24, 1876; Denver Public Library.
59. *Sundance Gazette*, September 1, 1893.
60. Wyoming State Archives, Department of State Parks and Cultural Resources, Cheyenne, Wyoming.
61. *Life and Adventures of Calamity Jane.*
62. McLaird, *Calamity Jane*, 44–47.
63. Spring, *Cheyenne and Black Hills*, 109–12; *Cheyenne Daily Leader*, June 6, 1876.
64. *Minneapolis Tribune*, April 22, 1904.
65. McLaird, *Calamity Jane*, 44–47.
66. *Life and Adventures of Calamity Jane.*
67. Secrest, *I Buried Hickok*, 57, 92–94.
68. Ibid.
69. Ibid.
70. deadwoodhistory.com.
71. *Oshkosh Daily Northwestern*, May 5, 1877.
72. *River Press*, March 8, 1882.
73. McKeown, *Them Was the Days*, 147.
74. *Oshkosh Daily Northwestern*, May 5, 1877.
75. *Basin Republican Rustler*, September 14, 1941.
76. Larson, *History of Wyoming*, 234–35; *Cheyenne Daily Leader*, July 7, 1877.
77. *Cheyenne Daily Leader*, July 7, 1877.
78. *Bismarck Weekly Tribune*, August 17, 1877.
79. *Black Hills Daily Times*, June 28, 1878.
80. Ibid.
81. *Black Hills Daily Times*, July 20, 1879.
82. *Life and Adventures of Calamity Jane.*
83. Ancestry.com; *Black Hills Daily Times*, December 3, 1879.
84. *Cheyenne Daily Sun*, June 3, 1879.
85. Johnson, *Happy as a Big Sunflower*, 179.
86. Ibid., 176.
87. *Life and Adventures of Calamity Jane.*
88. Secrest, *I Buried Hickok*, 93–95.
89. Jennewein, *Calamity Jane*, 32.
90. McAllister, *Gumbo Trails*, 266–68.

91. Historical Society of Old Stanley County, *Prairie Progress*, 474.

92. Brown and Willard, *Black Hills Trails*, 447; Cerney, *Fort Pierre-Deadwood*, 89–90.

93. Ibid.

94. *Saint Paul Globe*, August 23, 1880.

95. Brown and Willard, *Black Hills Trails*, 412–15.

CHAPTER 4

96. Ancestry.com.

97. Bell interview.

98. Bennett, *Old Deadwood Days*, 221. The date of this occurrence has been questioned.

99. *Morning Oregonian*, August 16, 1903.

100. Ancestry.com; Mathisen, "Calamity's Sister."

101. Larson, *History of Wyoming*, 159–62.

102. Whithorn and Whithorn, *Calamity's in Town*, 45.

103. Mathisen, "Calamity's Sister."

104. *Weekly Register Call*, February 25, 1882.

105. *Bismarck Tribune*, November 17, 1882; *Billings Herald*, November 16, 1882.

106. *Daily Yellowstone Journal*, December 9, 1882.

107. *Life and Adventures of Calamity Jane*.

108. McLaird, *Calamity Jane*, 119–20.

109. *Independent Record*, February 6, 1883.

110. *Spokane Press*, August 6, 1903.

111. *Laramie Weekly Boomerang*, March 25, 1884.

112. *Black Hills Daily Times*, March 28, 1884.

113. *Livingston Daily Enterprise*, March 14, 1884.

114. Stoll, *Silver Strike*, 21; Seagraves, *Soiled Doves*, 124–26.

115. *Livingston Daily Enterprise*, April 16, 1884; Whiteside, unpublished notes.

116. Whiteside, unpublished notes.

117. Ibid.; Kershner, "Calamity Jane."

118. *Daily Yellowstone Journal*, June 29, 1884.

119. *Bismarck Weekly Tribune*, July 4, 1884.

120. *Daily Enterprise*, August 16, 1884; McLaird, *Calamity Jane*, 126–29.

121. *Life and Adventures of Calamity Jane*.

122. *Laramie Daily Boomerang*, November 20, 1884.

123. *Carbon County Journal*, December 20, 1884.

124. *Livingston Daily Enterprise*, March 21, 1885.

125. *Uinta Chieftain*, November 14, 1885.

126. *Bismarck Weekly Tribune*, November 17, 1885.

127. *Carbon County Journal*, November 7, 1885; *Uinta Chieftain*, November 14, 1885.

128. *Laramie Weekly Sentinel,* July 31, 1886.

129. Wikipedia.org.

130. Etulain, *Calamity Jane*, 54; McLaird, *Calamity Jane*, 133–34; Wilbur, "Reminiscences of the Meeker Country," 277.

131. *Cheyenne Democratic Leader*, September 21, 1886; Etulain, *Calamity Jane*, 54.

132. Etulain, *Calamity Jane*, 55.

133. Ibid.

134. *Cheyenne Democratic Leader*, March 12, 1887; *Uinta Chieftain*, March 25, 1882.

135. Ibid.

136. Ibid.; *Lusk Herald*, July 8, 1887.

137. *Cheyenne Daily Sun*, August 16, 1887.

138. Ibid., September 2, 1887.

139. *Sundance Gazette*, September 2, 1887.

140. *Life and Adventures of Calamity Jane.*

141. Loveland, "Greybull."

142. *Cheyenne Daily Leader*, January 22, 1888.

143. *Wyoming Wind River Mountaineer*, "Pioneer Profiles."

144. *Freemont Clipper*, March 1888.

145. Ibid., June 14, 1888.

146. *Wyoming Wind River Mountaineer*, October 17, 1888.

147. *Big Horn Sentinel*, April 14, 1888; *Sundance Gazette*, April 27, 1888.

148. Certificate of marriage, Bingham County, Idaho Territory. A search for Lizzie (Elizabeth) Bard yielded a 1910 census that showed a Boise, Idaho residence.

149. *Cheyenne Weekly Sun,* January 9, 1889.

150. *Morning Oregonian,* June 2, 1889; *Oakland Tribune,* June 1, 1889.

151. Ibid.

152. Ibid.

153. Ibid.

154. Ibid.

155. Ibid.

156. Ibid.

157. *Livingston Daily Enterprise*, April 13, 1901.

158. Etulain, *Calamity Jane*, 42.

159. *Sundance Gazette*, January 10, 1890.

160. *Laramie Daily Boomerang*, January 15, 1890.

161. *Omaha Daily Bee*, June 10, 1890.

162. *Omaha World Herald*, February 3, 1892.

163. *Rock Springs Miner*, December 28, 1893; McLaird, *Calamity Jane*, 145.

CHAPTER 5

164. Loveland, "Greybull."

165. *Wyoming Wind River Mountaineer*, "Pioneer Profiles"; Loveland, "Greybull."

166. Ibid.

167. Loveland, "Greybull."

168. *Wyoming Wind River Mountaineer*, "Pioneer Profiles"; Loveland, "Greybull."

169. *Gazette Telegraph*, November 18, 1900.

170. *Sheridan Post*, November 29, 1900.

171. *Omaha World Herald*, April 6, 1901. The outcome of the trial was not found.

172. *Basin Republican Rustler*, July 13, 1950; *Thermopolis Independent*, February 8, 1922.

173. *Basin Republican Rustler*, June 4, 1909; December 14, 1919.

174. *Big Horn County Rustler*, June 4, 1915.

175. *Greybull Standard*, December 19, 1919.

176. Ibid., February 7, 1960.

CHAPTER 6

177. Mathisen, "Calamity's Sister"; *Wyoming State Journal*, December 30, 1962.

178. Ancestry.com.

179. Larson, *History of Wyoming*, 162.

180. Mathisen, "Calamity's Sister," 29.

181. Whiteside, unpublished notes.

182. Johnson, *Butch Cassidy*, 120.

183. Call, *Star Valley and Its Communities*.

184. *Uinta Chieftain*, September 19, 1885.

185. *Cheyenne Democratic Leader*, October 12, 1886.

186. *Laramie Daily Boomerang*, October 5, 1895.

187. Wyoming State Archives.

CHAPTER 7

188. *Salt Lake Herald*, November 18, 1895; familysearch.org.

189. *Ogden Standard Examiner*, August 8, 1908.

190. Ibid.

191. Ibid., August 20, 1908

192. Ibid., August 21, 1908.

193. Ibid., January 28, 1903.

194. Ibid., June 26, 1923.

195. Wyoming State Archives.

196. *Ogden Standard Examiner*, December 23, 1895.

197. *Laramie Daily Boomerang*, January 6, 1896; *Idaho Daily Statesman*, May 13, 1896.

198. Wyoming State Archives.

199. Ibid.

200. *Wyoming Wind River Mountaineer*, April 22, 1896.

201. *Idaho Daily Statesman*, May 13, 1896.

202. *Evanston News Register*, May 2, 1896.

203. *Idaho Daily Statesman*, May 13, 1896.

204. *Laramie Semi-Weekly Boomerang*, April 27, 1896; *Rock Springs Miner*, September 17, 1896; *Evanston News Register*, September 12, 1896.

205. Wyoming State Archives.

206. Idaho Historical Society; Wyoming State Archives.

207. *Laramie Semi-Weekly Boomerang*, July 19, 1897; *Atlas of Wyoming Outlaws*; Kelly, *Outlaw Trail*, 60.

208. History.utah.gov/burials.

209. Wyoming State Archives.

210. Ibid.

211. Wyoming State Archives; ancestry.com.

CHAPTER 8

212. Mathisen, "Calamity's Sister."

213. *Wyoming Semi-Weekly Tribune*, March 24, 1909; *Progressive Men of Wyoming*, 950–51; Stone, *Uinta County*, 176.

214. *Carbon County Journal*, December 10, 1891.

215. *Rock Springs Miner*, October 19, 1892.

216. *Bill Barlow's Budget*, April 13, 1891.

217. *Cheyenne Daily Leader*, April 29, 1892.

218. Kelly, *Outlaw Trail*, 55.

219. *Laramie Daily Boomerang*, July 28, 1893; Kelly, *Outlaw Trail*, 56.

220. Kelly, *Outlaw Trail*, 56.

221. Ibid., 56–58.

222. *San Francisco Call*, April 3, 1898; *Laramie Republican*, August 12, 1922.

223. *San Francisco Call*, April 3, 1898.

224. Kelly, "Great 'Gunplay' Maxwell."

225. *Ogden Standard Examiner*, May 27, 1902.

226. Mathisen, "Calamity's Sister"; *Wyoming Times*, July 8, 1915; September 20, 1917.

227. *Saratoga Sun*, May 12, 1892; *Salt Lake Tribune*, March 25, 1892; *Wyoming Wind River Mountaineer*, February 5, 1896.

228. *Wyoming Press*, May 22, 1897.

CHAPTER 9

229. *Salt Lake Herald*, January 2, 1894.

230. *Life and Adventures of Calamity Jane*.

231. *Deadwood Daily Times*, October 5, 1895.

232. Ibid.

233. Ibid.; *Sioux City Journal*, October 12, 1895.

234. *Black Hills Daily Times*, November 5, 1895; November 9, 1895; McLaird, *Calamity Jane*, 152.

235. *Hot Springs Star*, 1895; *Sioux City Journal*, November 17, 1895.

236. McLaird, *Calamity Jane*, 152–54.

237. *Life and Adventures of Calamity Jane*.

238. Ibid.

239. *Daily Inter Ocean*, January 28, 1896.

240. *Bill Barlow's Budget*, February 5, 1896.

241. *Minneapolis Journal*, March 30, 1896.

242. *Laramie Daily Boomerang*, June 8, 1896; *Wyoming Semi-Weekly Tribune*, June 4, 1896.

243. *Klondike Nugget*, June 23, 1896.

244. Ibid.

245. Whiteside, unpublished notes; McLaird, *Calamity Jane*, 163.

246. *Natrona County Tribune*, October 6, 1898; family search.org.

247. *Billings Gazette*, February 17, 1899; *Helena Independent*, March 7, 1899.

248. *Butte Daily Inter Mountain*, April 8, 1899.

249. *Livingston Park County News,* June 16, 1922.

250. *Laramie Republican,* October 18, 1897; November 13, 1897; McLaird, *Calamity Jane,* 26–27.

251. *Billings Gazette,* January 8, 1901; *Omaha World Herald,* April 13, 1901.

252. *Livingston Daily Enterprise,* April 13, 1901; *Anaconda Standard,* July 9, 1901.

253. *St. Louis Republican,* July 28, 1901.

254. *Cheyenne Daily Leader,* October 9, 1901.

255. *Livingston Daily Enterprise,* December 21, 1901; Whithorn and Whithorn, *Calamity's in Town,* 13.

256. *Las Cruces Progress,* June 21, 1902.

257. Wyman, *Frontier Woman,* 59.

258. *Butte Daily Inter Mountain,* April 17, 1902.

259. *Livingston Daily Enterprise,* April 24, 1902; Whithorn and Whithorn, *Calamity's in Town,* 15.

260. *Livingston Daily Enterprise,* June 7, 1902; Whithorn and Whithorn, *Calamity's in Town,* 19.

261. *Rosebud County News,* November 20, 1902.

262. *Anaconda Standard,* December 13, 1902.

263. *Bits and Pieces,* "Life Was Never Dull," 5.

264. *Livingston Daily Enterprise,* August 8, 1903; Whithorn and Whithorn, *Calamity's in Town,* 32.

265. *Minneapolis Journal,* April 22, 1904.

266. Ibid.

267. Ibid.

268. *Crook County Monitor,* November 23, 1898.

269. *Pony Express,* "Clementine Canary."

270. *Deadwood Telegram,* August 11, 1924; Coursey, *Beautiful Black Hills,* 104.

271. *Minneapolis Journal,* April 22, 1904.

CHAPTER 10

272. St. Anthony probate court records.

273. *Star Valley Independent,* August 18, 1905.

274. Ibid.

275. *Wyoming Semi-Weekly Tribune,* August 25, 1905.

276. *Guernsey Gazette,* September 8, 1905.

277. Idaho Historical Society, prison record.

278. St. Anthony probate court records.

279. Ibid.

280. *Idaho Daily Statesman*, December 1, 1905.

281. *Teton Peak-Chronicle*, December 1905.

282. Idaho Historical Society, prison records.

CHAPTER 11

283. Familysearch.org.

284. Ibid.

285. Whiteside, unpublished notes.

286. Walston, *Golden Age of Weiser*, 12, 123.

287. *Weiser Leader*, September 20, 1884. Courtesy of Ken Walston.

288. Ibid., November 4, 1887. Courtesy of Ken Walston.

289. Ibid., October 1, 1886, Courtesy of Ken Walston.

290. Weiser court records. Courtesy of Ken Walston.

291. Familysearch.org; Whiteside, unpublished notes.

292. *Weiser American*, February 19, 1909; Whiteside, unpublished notes.

293. Ibid.

294. Familysearch.org.

295. *Weiser American*, February 20, 1908; Whiteside, unpublished notes.

296. Familysearch.org.

297. McLaird, *Calamity Jane*, 13.

298. Ibid., 12.

299. Ancestry.com.

300. Familysearch.org.

301. Ransom, "Country Schoolma'am," 67–87.

302. Ibid.

303. *Star Valley Independent*, May 28, 1913.

304. *Wyoming Semi-Weekly Tribune*, February 2, 1904; *Cheyenne Daily Leader*, February 2, 1904.

305. *Wyoming Semi-Weekly Tribune*, December 20, 1904; Wyoming State Archives, prison record.

306. *Wyoming Semi-Weekly Tribune*, November 20, 1903.

307. *Star Valley Independent*, January 5, 1906.

CHAPTER 12

308. Mathisen, "Calamity's Sister."

309. Juanda Daniels Whisman to Doris Sermon, October 27, 1999. Letter in possession of Richard W. Etulain.

310. Britton, *Trumpeter's Dell*, 75, 125.

311. Juanda Daniels Whisman to Doris Sermon, October 27, 1999. Letter in possession of Richard W. Etulain.

312. Britton, *Trumpeter's Dell*, 116, 117.

313. Whisman e-mail.

314. Sermon interview, July 2012.

315. Ibid.

316. E-mail from Sue Sermon's mother, Doris, to Sue, September 19, 1999. In possession of Richard Etulain; Mathisen, "Calamity's Sister."

317. Ibid.

318. Ross, *Westward the Women*, 133–34; Whiteside, unpublished notes.

319. *Wyoming Industrial Journal*, April 1, 1902; *Wyoming Dispatch*, July 4, 1902.

320. Sparling, *Southern Idaho Ghost Towns*, 54.

321. Brown and Willard, *Black Hills Trails*, 413; Whiteside, unpublished notes.

CHAPTER 13

322. Familysearch.org.

323. E-mail from Larry Doxford, Doxford family history.

324. *Nevada Journal of Mines and Geology*.

325. Familysearch.org, 1910 census.

326. United States Department of the Interior.

327. Ibid.

328. Utah Department of Administrative Services, Division of Archives and Records.

329. *Panguitch Progress*, April 26, 1916.

330. United States Department of the Interior.

331. *Panguitch Progress*, May 28, 1916.

332. Ibid., April 28, 1916.

333. *Roosevelt Standard*, September 21, 1917; United States Department of the Interior.

334. United States Department of the Interior.

335. State of California State Board of Health, Bureau of Vital Statistics, standard certificate of death.

336. *Bakersfield Californian*, November 2, 1918.

337. Utah Department of Administrative Services, Division of Archives and Records.

BIBLIOGRAPHY

NEWSPAPERS

Afton Star Valley Independent (Afton, WY).
Anaconda Standard (Anaconda, MT).
Basin Republican Rustler (Basin, Big Horn County, WY).
Big Horn County Rustler (Basin, Big Horn County, WY).
Big Horn Sentinel (Buffalo, WY).
Bill Barlow's Budget (Douglas, WY).
Billings Gazette (Billings, MT).
Billings Herald (Billings, MT).
Bismarck Weekly Tribune (Bismarck, ND).
Black Hills Daily Times (Deadwood, Dakota Territory).
Carbon County Journal (Rawlins, WY).
Cheyenne Daily Leader (Cheyenne, WY).
Cheyenne Daily Sun (Cheyenne, WY).
Cheyenne Democratic Leader (Cheyenne, WY).
Cheyenne Weekly Sun (Cheyenne, WY).
Chicago Tribune (Chicago, IL).
Crook County Monitor (Sundance, WY).
Daily Butte Inter Mountain (Butte, MT).
Daily Enterprise (Sheridan, WY).
Daily Inter Ocean (Chicago, IL).
Daily Yellowstone Journal (Miles City, MT).

BIBLIOGRAPHY

Deadwood Daily Times (Deadwood, Dakota Territory).

Deadwood Telegram (Deadwood, Dakota Territory).

Evanston News Register (Evanston, WY).

Freemont Clipper (Lander, WY).

Gazette Telegraph (Salt Lake City, UT).

Greybull Standard (Greybull, WY).

Guernsey Gazette (Guernsey, WY).

Helena Independent (Helena, MT).

Hot Springs Star (Hot Springs, SD).

Idaho Daily Statesman (Boise, ID).

Independent Record (Helena, MT).

Klondike Nugget (Dawson, Yukon Territory).

Lander Times (Lander, WY).

Laramie Boomerang (Laramie, WY).

Laramie Republican (Laramie, WY).

Laramie Semi-Weekly Boomerang (Laramie, WY).

Laramie Weekly Boomerang (Laramie, WY).

Laramie Weekly Sentinel (Laramie, WY).

Las Cruces Progress (Las Cruces, NM).

Livingston Daily Enterprise (Livingston, MT).

Livingston Park County News (Livingston, MT).

Livingston Post (Livingston, MT).

Lusk Herald (Lusk, WY).

Minneapolis Journal (Minneapolis, MN).

Minneapolis Tribune (Minneapolis, MN).

Montana Post (Virginia City, Montana Territory).

Morning Oregonian (Portland, OR).

Natrona County Tribune (Casper, WY).

Oakland Tribune (Oakland, CA).

Ogden Standard Examiner (Ogden, UT).

Omaha Daily Bee (Omaha, NE).

Omaha World Herald (Omaha, NE).

Oshkosh Daily Northwestern (Oshkosh, WI).

Panguitch Progress (Panguitch, UT).

River Press (Fort Benton, MT).

Rock Springs Miner (Rock Springs, WY).

Roosevelt Standard (Roosevelt, UT).

Rosebud County News (Forsyth, MT).

Saint Paul Globe (Saint Paul, MN).

BIBLIOGRAPHY

Salt Lake Herald (Salt Lake City, UT).

Salt Lake Tribune (Salt Lake City, UT).

San Francisco Call (San Francisco, CA).

Saratoga Sun (Saratoga, WY).

Sheridan Post (Sheridan, WY).

Sioux City Journal (Sioux City, IA).

Spokane Press (Spokane, WA).

Star Valley Independent (Afton, WY).

St. Louis Republican (St. Louis, MO).

Sundance Gazette (Sundance, WY).

Teton Peak-Chronicle (St. Anthony, ID).

Thermopolis Independent (Thermopolis, WY).

Uinta Chieftain (Evanston, WY).

Weekly Register Call (Central City, CO).

Weiser American (Weiser, ID).

Weiser Leader (Weiser, ID).

Wyoming Dispatch (Cody, WY).

Wyoming Industrial Journal (Cheyenne, WY).

Wyoming Press (Evanston, WY).

Wyoming Semi-Weekly Tribune (Cheyenne, WY).

Wyoming State Journal (Laramie, WY).

Wyoming Times (Evanston, WY).

Wyoming Wind River Mountaineer (Lander, WY).

INTERNET SOURCES

ancestry.com.

deadwoodhistory.com.

familysearch.org.

geni.com.

history.Utah.gov/burials.

Kershner, Jim. "Calamity Jane: Part Cheers, Mostly Booze." *Spokesman-Review.* http://www.spokesman.com/stories/2006/feb/26/calamity-jane-part-cheers-mostly-booze.

wikipedia.org.

wyomingtrailsandtales.com.

BIBLIOGRAPHY

COURT RECORDS, HISTORICAL SOCIETIES AND STATE ARCHIVES

Idaho State Historical Society, Public Archives and Research Library, Boise, Idaho.

Mercer County census records, Mercer County, Missouri.

Oregon Historical Society, Portland, Oregon.

Snake River Heritage Center Museum, Weiser, Idaho.

St. Anthony probate court records, St. Anthony, Idaho.

State of California State Board of Health Bureau of Vital Statistics. Standard Death Certificate, Sacramento, California.

Utah Department of Administrative Services, Division of Archives and Records, Salt Lake City, Utah.

Weiser, Washington County, Idaho Public Records.

Wyoming State Archives, Department of State Parks and Cultural Resources, Cheyenne, Wyoming.

INTERVIEWS

Telephone interview with Tom Bell, Lander historian, November 2011.

Telephone interview with Doris Sermon, July 2012.

E-MAIL SOURCES

Doris to daughter Sue Sermon, September 19, 1999. In possession of Richard Etulain.

Doxford, Larry, to author.

Walston, Ken, board of director for Snake River Heritage Center, to author.

Whisman, Michael, grandson of Doris Daniels Whisman, to author.

PERIODICALS AND ARTICLES

Bits and Pieces. "Life Was Never Dull for Della." Vol. 3, no. 9 (1967). Denver Public Library.

Kelly, Bill. "The Great 'Gunplay' Maxwell, Wild Bunch Wannabe." *True West*, September 1996.

Loveland, N.E. "Greybull: The Town." Works Progress Administration, n.d.

Mathisen, Jean A. "Calamity's Sister." *True West*, December 1996.

Mitchell, Victoria E. "History of the Golden Anchor Mine, Idaho County, Idaho Staff Report." *Idaho Geological Survey* (June 2000).

Nevada Journal of Mines and Geology. Reno, NV.

Pony Express. "Clementine Canary." April 1947. Denver Public Library.

Ransom, Lucy Sophia (Adams). "Country Schoolma'am." Edited by Jay Ellis Ransom. *Oregon Historical Quarterly* 87, no. 1 (Spring 1986).

Whiteside, William R. Unpublished notes. In the possession of Richard Etulain.

Wilbur, Ed P. "Reminiscences of the Meeker Country." *Colorado Magazine* 23, no. 6. Denver Public Library.

Wyoming Wind River Mountaineer. "Pioneer Profiles: John and Lena Canary Borner." Vol. 5, no. 4 (October/December 1989).

United States Department of the Interior. National Park Service. National Register of Historic Places Form. Panguitch, Utah.

Books

Bennett, Estelline. *Old Deadwood Days*. Lincoln: University of Nebraska Press, 1982.

Britton, Afton. *Trumpeter's Dell*. Idaho Falls, ID: Falls Printing, 2011.

Brown, Jesse, and A.M. Willard. *Black Hills Trails*. Rapid City, SD: Rapid City Journal, 1924.

Calamity Jane. *Life and Adventures of Calamity Jane: By Herself*. N.p., 1896.

Call, Lee. *Star Valley and Its Communities*. Revised. Afton, WY: Star Valley Independent, 1970.

Cerney, Jan. *The Fort Pierre-Deadwood Gold Trail*. Collierville, TN: InstantPublisher, 2006.

Coursey, O.W. *Beautiful Black Hills*. Mitchell, SD: Educator Supply Company, 1926.

Etulain, Richard W. *Calamity Jane: A Reader's Guide*. Norman: University of Oklahoma Press, 2015.

Frye, Elmore L. *Atlas of Wyoming: Outlaws at the Territorial Penitentiary*. Laramie, WY: Jelm Mountain Publishers, 1990.

BIBLIOGRAPHY

Historical Society of Old Stanley County. *Prairie Progress of West Central South Dakota*. Sioux Falls, SD: Midwest Beach, Inc., 1968.

Jennewein, Leonard. *Calamity Jane of the Western Trails*. Huron, SD: Dakota Books, 1953.

Johnson, Pamela Call. *Butch Cassidy and the Wild Bunch in Star Valley, Wyoming, 1889–1896*. Shelley, ID: CJJJ Publishing.

Johnson, Rolf. *Happy as a Big Sunflower*. Lincoln: University of Nebraska, Bison Books, 2000.

Kelly, Charles. *The Outlaw Trail: A History of Butch Cassidy & His Wild Bunch*. Lincoln: University of Nebraska Press, 1996.

Larson, T.A. *History of Wyoming*. 2nd ed., revised. Lincoln: University of Nebraska Press, 1978.

Leedy, Carl. *Golden Days in the Black Hills*. Rapid City, SD: Holgrem's, Incorporated, 1961.

Lindmier, Thomas, and Cynde Georgen. *South Pass City: Wyoming's City of Gold*. Virginia Beach, VA: Donning Publishing Company, 2004.

McAllister, Laura Kirley. *Gumbo Trails*. N.p., n.d.

McKeown, Martha Ferguson. *Them Was the Days: An American Saga of the '70s*. New York: Macmillan Co., 1950.

McLaird, James D. *Calamity Jane: The Woman and the Legend*. Norman: University of Oklahoma Press, 2005.

Mercer County Pioneer Traces. Vol. 1. Princeton, MO: Missouri Mercer County Genealogical Society, 1997.

Progressive Men of Wyoming. Chicago: A.W. Bowen & Co., 1903.

Ross, Nancy Wilson. *Westward the Women*. New York: North Point Press, 1985.

Seagraves, Anne. *Soiled Doves*. Post Falls, ID: Wesanne Publishing, 1994.

Secrest, William B., ed. *I Buried Hickok: The Memories of White Eye Anderson*. College Station, TX: Creative Publishing Co., 1980.

Sherlock, James L. *South Pass and Its Tales*. Greybull, WY: Wolverine Gallery, 1978.

Sparling, William C. *Southern Idaho Ghost Towns*. Caldwell, ID: Caxton Press, 1974.

Spring, Agnes Wright. *The Cheyenne and Black Hills Stage and Express Route*. Lincoln, NE: Bison Books, 1948.

Stoll, William T., as told to H.W. Whicker. *Silver Strike: The True Story of Silver Mining in the Coeur d'Alenes*. Boston: Little Brown and Company, 1932.

Stone, Elizabeth A. *Uinta County: Its Place in History*. Laramie, WY: Laramie Printing Company, 1924.

Walston, Ken. *The Golden Age of Weiser, Idaho, Book 1, 1879–1883*. Cambridge, ID: Cambridge Litho, 2015.

Whithorn, Bill, and Doris Whithorn. *Calamity's in Town*. Livingston, MT: Livingston Enterprises, n.d.

Wyman, Walker D. *Frontier Woman: The Life of a Woman Homesteader on the Dakota Frontier*. Madison, WI: River Falls Press, 1972.

Young, Harry. *Hard Knocks: A Life Story of the Vanishing West*. Portland, OR: Wells & Co., 1915.

INDEX

INDEX

INDEX

ABOUT THE AUTHOR

Jan Cerney began writing after she retired from teaching, concentrating mostly on South Dakota history. She has written five books and co-authored four additional books for Arcadia Publishing Company. Among the books she has written and those she co-authored with Roberta Sago are: *Badlands National Park, Mitchell's Corn Palace, Gregory and Charles Mix Counties, Lakota Sioux Missions, Pierre and Fort Pierre, Spearfish, Black Hills National Forest: Harney Peak and the Historic Fire Lookout Towers, Black Hills Gold Rush Towns: Volume I* and *Black Hills Gold Rush Towns: Volume II.* She has also written a four-book novel series, the Mission Quilts series, for the American Quilter's Society.

Jan has presented at several history conferences, discussing several of her books or presenting papers. She appeared as a historian and author on an eighty-two-minute French film entitled *Calamity Jane: Wild West Legend*, directed and produced by French actor Gregory Monro with the Arte France network and Temps Noir, Paris.

Jan and her husband, Bob, live on a ranch near the South Dakota Badlands.

Visit us at
www.historypress.net

···

This title is also available as an e-book